ROMAN PORTRAITS IN CONTEXT

Imperial and Private Likenesses
from the Museo Nazionale Romano

Emory University – Museum of Art and Archaeology – Atlanta 7/14/1988 – 1/3/1989

EMORY UNIVERSITY MUSEUM OF ART AND ARCHAEOLOGY – ATLANTA

SOPRINTENDENZA ARCHEOLOGICA DI ROMA – MUSEO NAZIONALE ROMANO

ROMAN PORTRAITS IN CONTEXT

Imperial and Private Likenesses
from the Museo Nazionale Romano

Maxwell L. Anderson Leila Nista

DE LUCA EDIZIONI D'ARTE

Roman Portraits in Context
Imperial and Private Likenesses
from the Museo Nazionale Romano

Emory University Museum
of Art and Archaeology - Atlanta
Telefax: 404-727-4292

Ministero per i Beni Culturali e Ambientali
Soprintendenza Archeologica di Roma
Museo Nazionale Romano
Telefax: 0039-6-4814125

Unità Cataloghi d'Arte De Luca

Direttore editoriale
Stefano De Luca

Responsabile editoriale
Francesca Pagnotta

Responsabile tecnico
Giovanni Portieri

© 1988 De Luca Edizioni d'Arte S.p.A., Roma

Via di S. Anna, 16 – 00186 Roma
Telefax: 0039-6-6864430

on the cover:
Rome, Via Latina, Vigna Codini, Columbarium II

ISBN 88-7813-138-5

The catalogue for the exhibition was made possible
by a generous grant from

ENICHEM AMERICAS INC.

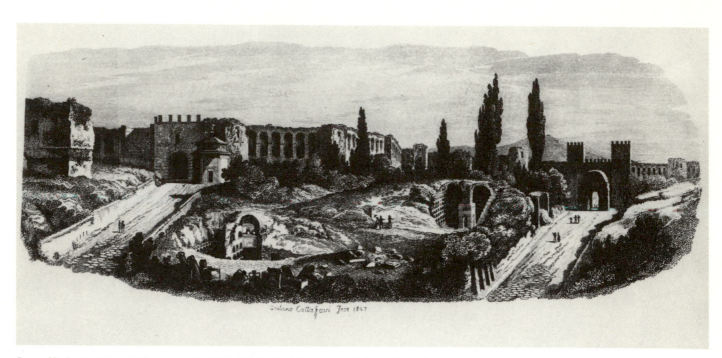

Rome, Via Latina: Vigna Codini, excavation 1840, of Columbaria Pomponius Hylas and "Familiae Marcellae et Aliorum". From P. Campana, Diss. Pont. Acc. XI, 1852, p. 316, F.U. 5278. Fototeca Unione, at the American Academy in Rome.

Foreword

The loan project of which this catalogue is a part represents a new direction for the Emory University Museum of Art and Archaeology.

The Emory University Museum International Loan Project (EUMILOP) was devised to encourage substantive cooperative efforts between archaeological museums and sites in this country and abroad. With a view toward the future, when acquisitions of antiquities will become increasingly difficult for American museums owing to financial and ethical considerations, loan projects of this kind will provide one avenue for American museums with limited resources.

The generosity of the Soprintendenza Archeologica of Rome in lending these twenty-two masterworks, which include some of the most significant Roman portrait sculptures known, cannot be overstated. The American museum-going public and the archaeological community are deeply endebted to Professor Adriano La Regina, Superintendent of Antiquities, for allowing this project to go forward. It is, furthermore, a signal honor for Emory to be the first American museum to receive a loan exhibition entirely from the Museo Nazionale Romano. Dr. Leila Nista, Inspector of Archaeology at the Museo Nazionale Romano, was indispensable in every phase of the project, from selecting the works to be exhibited, to co-authoring the catalogue, and deserves our thanks as well. The origins of the project as a whole may be traced to Prof. Antonio Giuliano, who kindly invited me to serve on the faculty of the University of Rome in the spring of 1987, and facilitated this undertaking through his support and wise counsel. I would further like to thank those responsible for the restoration of the objects of the exhibition: Dr. M. R. Di Mino, coordinator of the restoration laboratory of the Museo Nazionale Romano, and the firm CONART. Dr. M.T. Natale oversaw the photography for the catalogue, and Architect M. Petrecca facilitated access to the Vigna Codini Columbaria. Among those in Rome who aided in the completion of the catalogue, there is only space to thank Dr. Bernard Andreae, Director of the German Archaeological Institute, for the use of the library and other resources of the Institute. The president of Emory University, Dr. James T. Laney, and the Museum's Board of Directors were consistently encouraging in the development of this initiative, which would not have been possible without their help and that of the Museum's staff. The catalogue was made possible through the considerable generosity of EniChem Americas Inc. and I am very grateful to its president, Alfredo de Marzio, for seeing the value in this project when it was first presented to him.

Maxwell L. Anderson
Atlanta

7

CATALOGUE

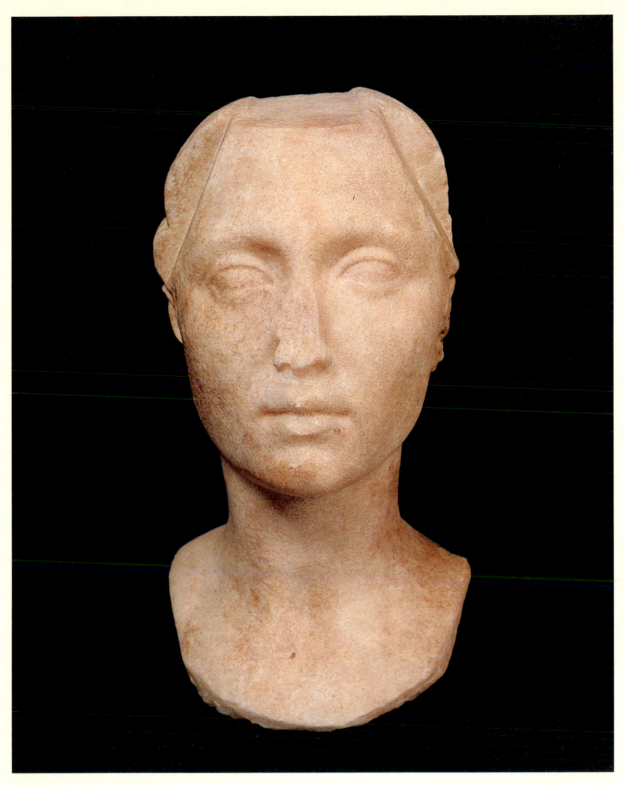

Portrait of a woman – Tivoli (cat. no. 12)

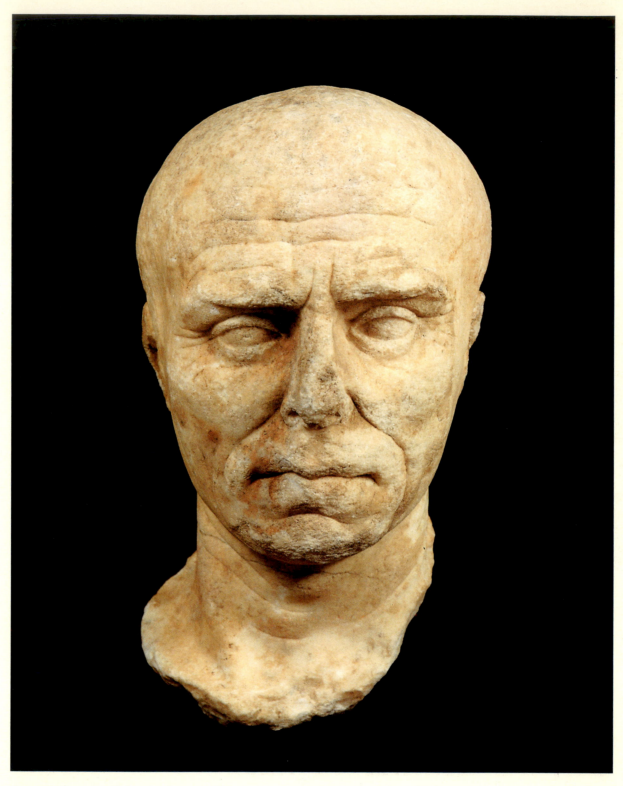

Portrait of a man – Palestrina (cat. no. 2)

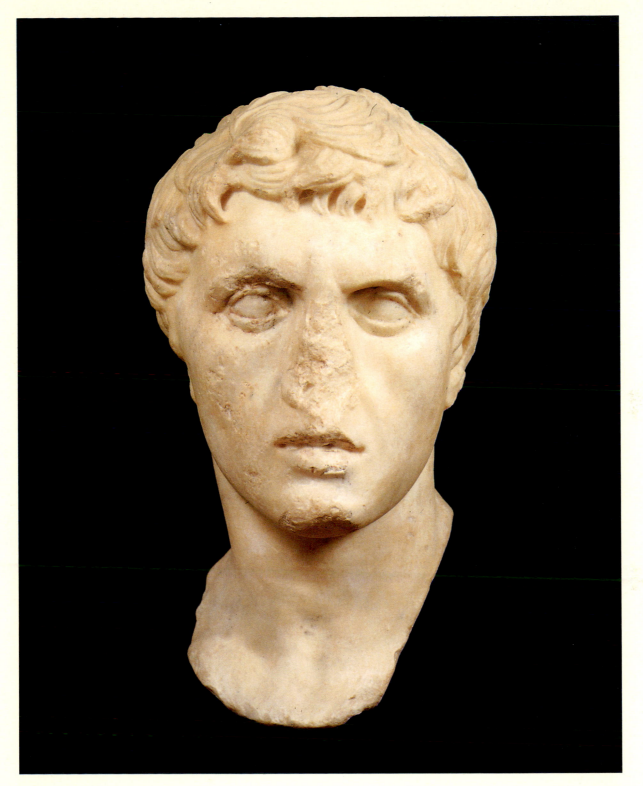

Portrait of a man – Rome (cat. no. 1)

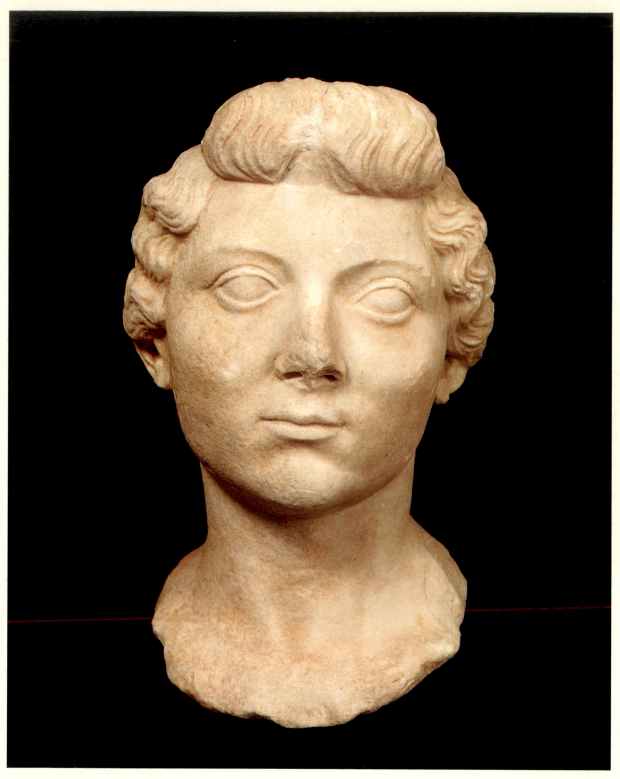

Portrait of a woman – Palestrina (cat. no. 3)

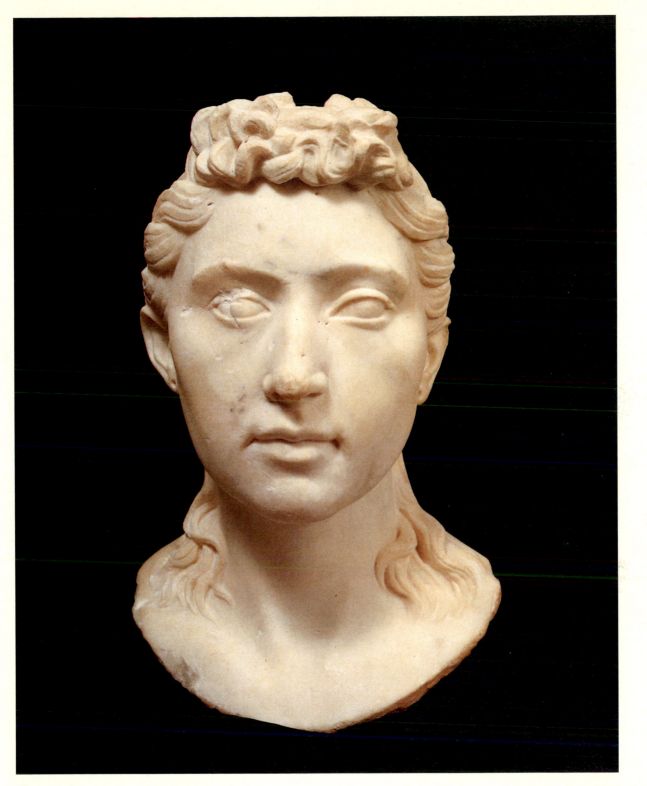

Portrait of a woman – Rome (cat. no. 13)

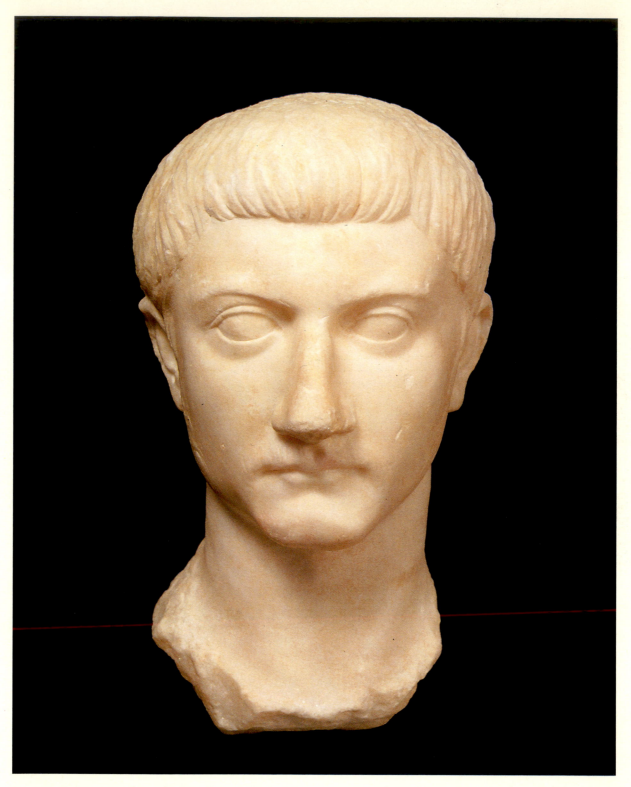

Portrait of Drusus Minor – Mentana (cat. no. 5)

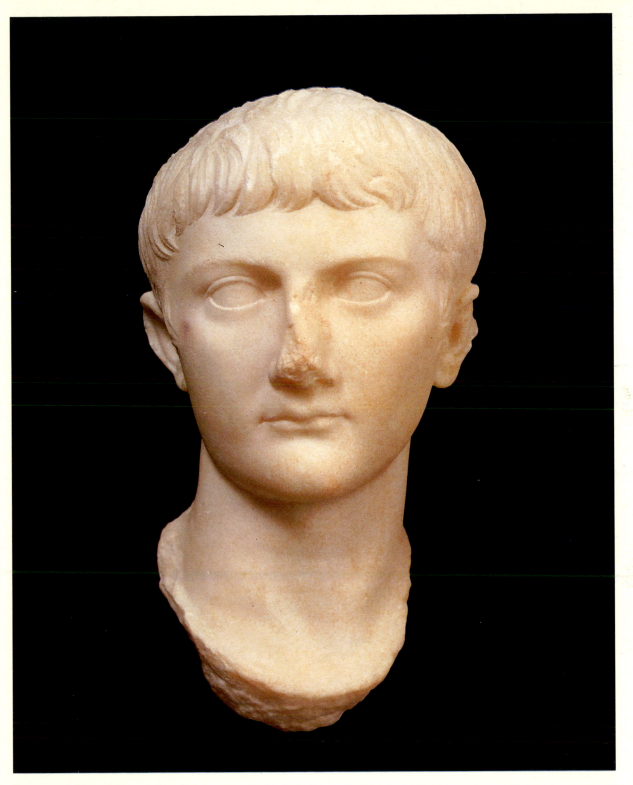

Portrait of Germanicus – Mentana (cat. no. 6)

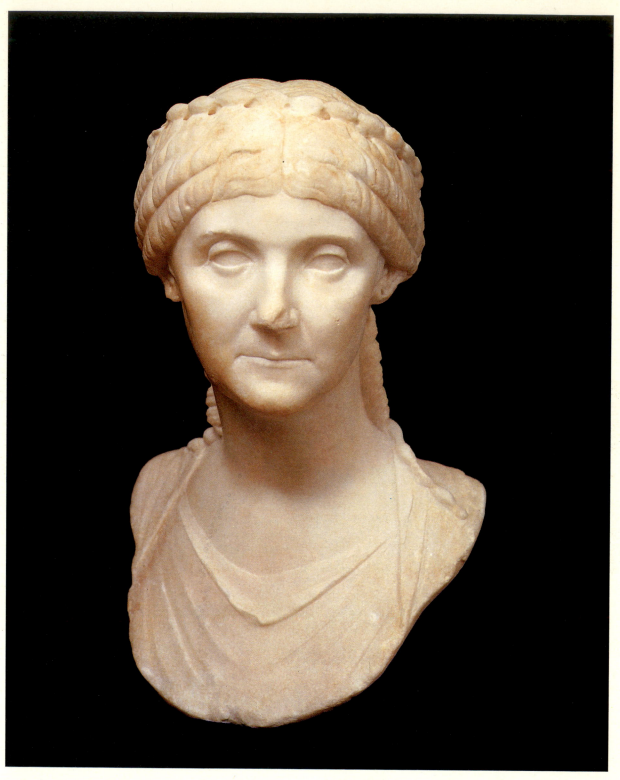

Bust of a woman – Mentana (cat. no. 7)

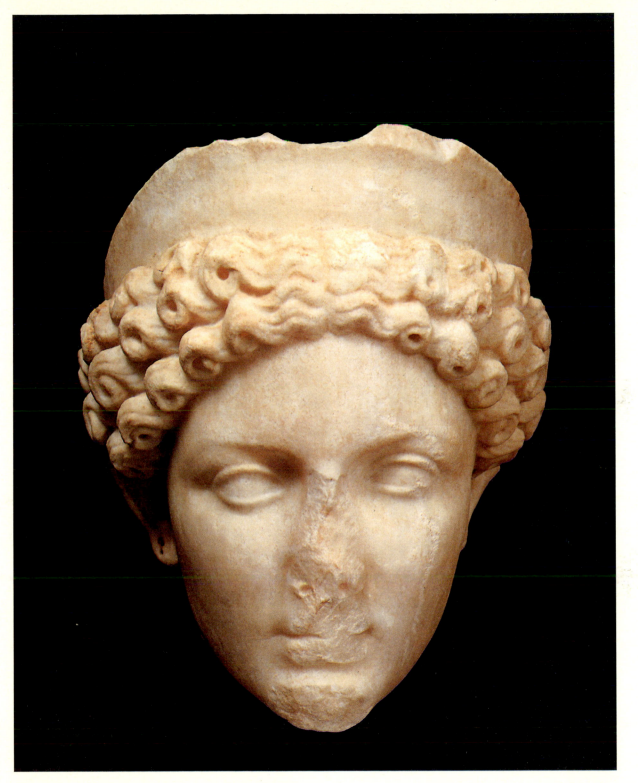

Portrait perhaps of Claudia Octavia – Rome (cat. no. 14)

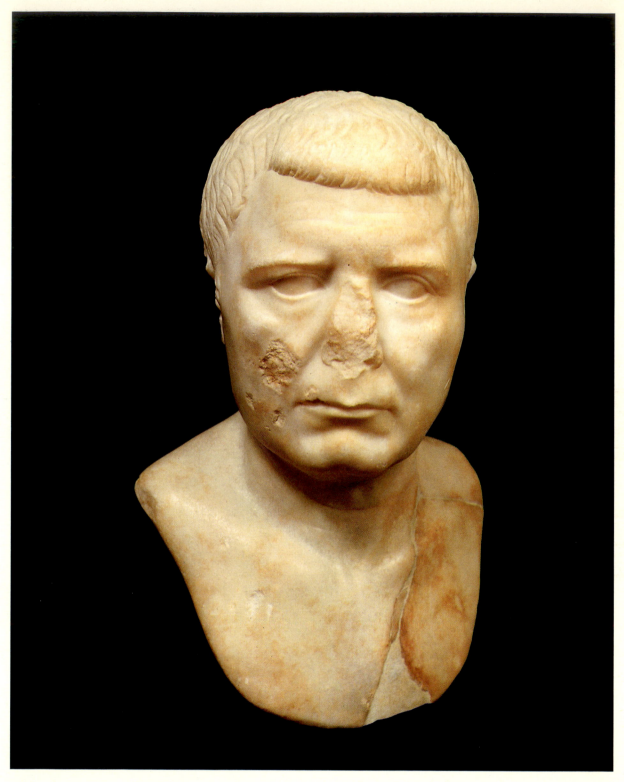

Portrait Bust of a man – Rome (cat. no. 15)

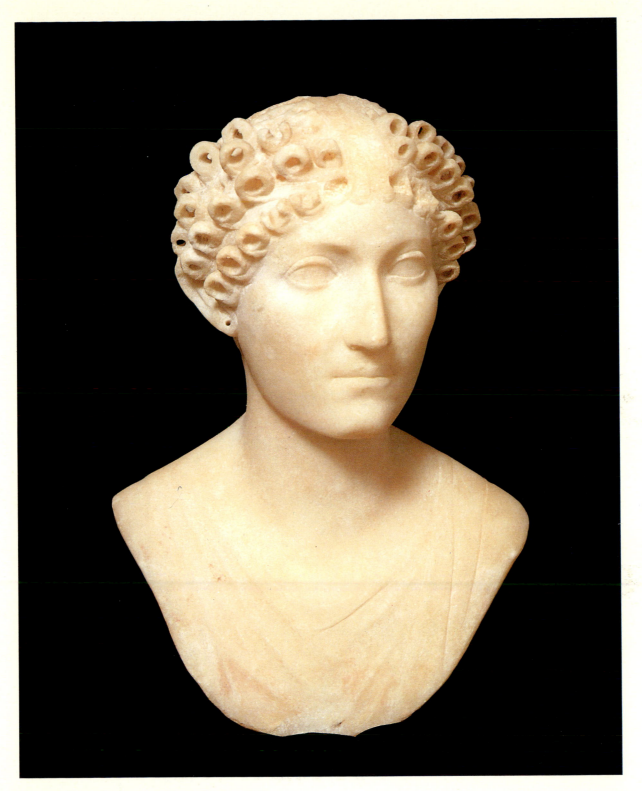

Portrait Bust of a woman – Rome (cat. no. 16)

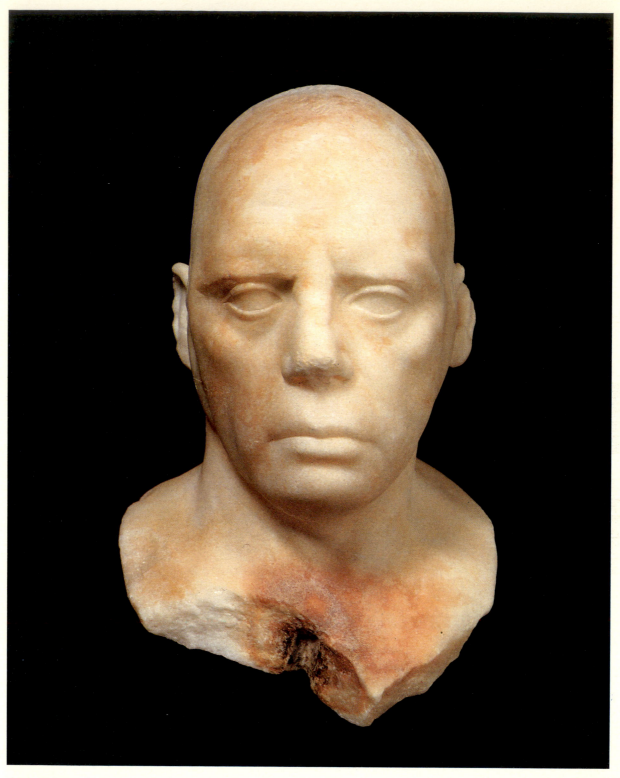

Portrait Bust of a man – Rome (cat. no. 17)

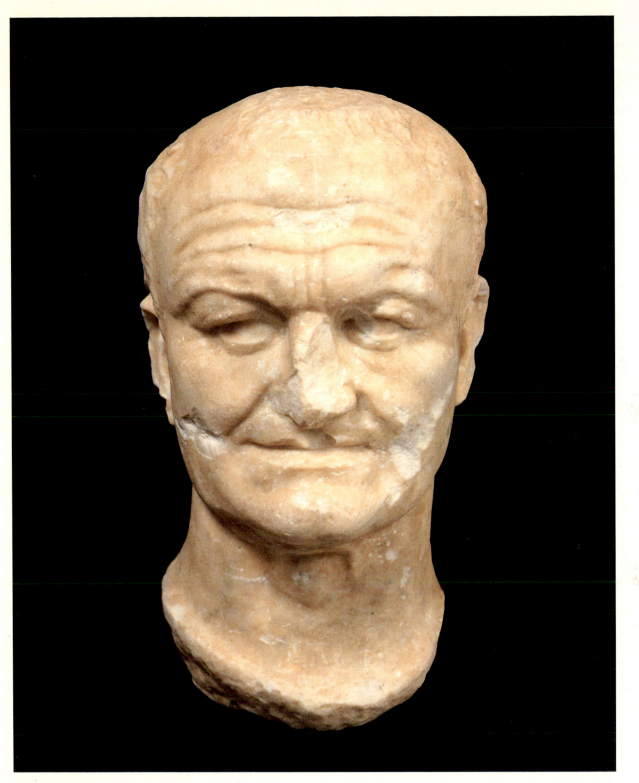

Portrait of Vespasian – Rome (cat. no. 8)

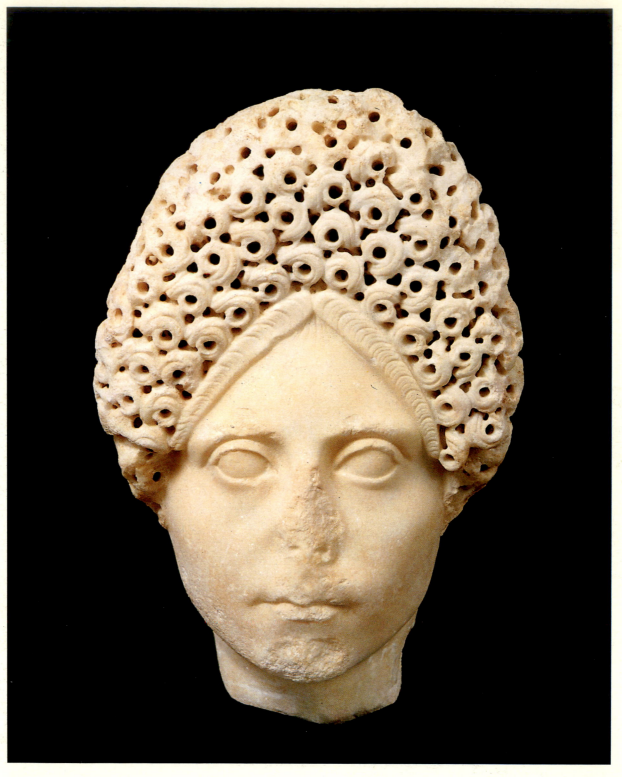

Portrait of a woman – Palestrina (cat. no. 4)

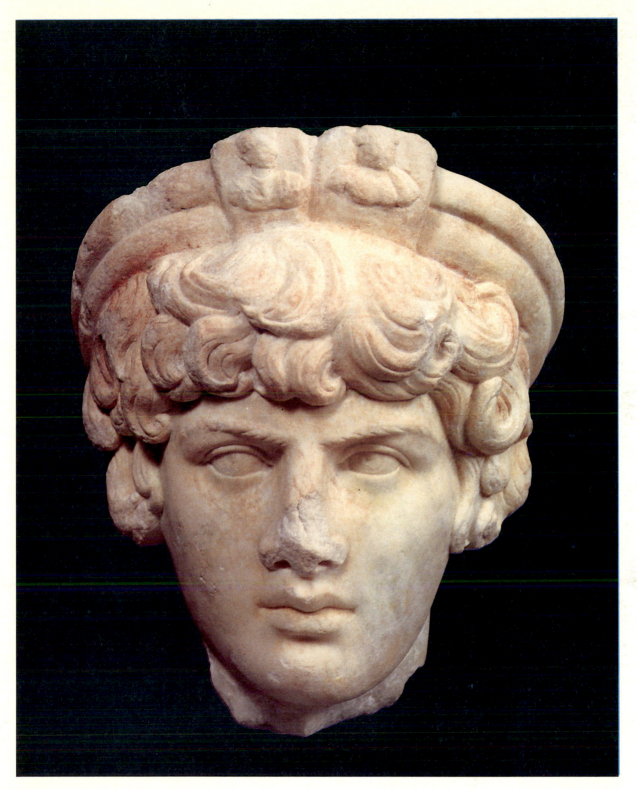

Portrait of Antinous – Ostia (cat. no. 18)

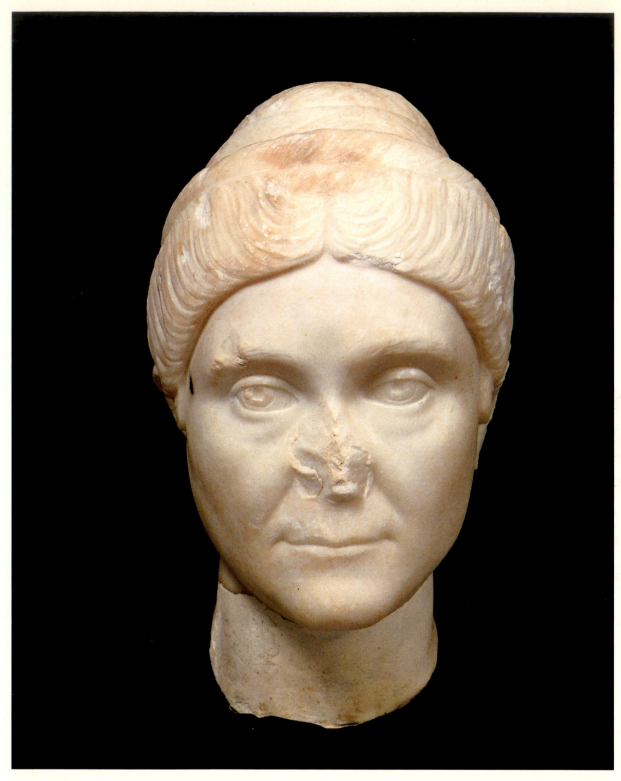

Portrait of an older woman – Rome (cat. no. 20)

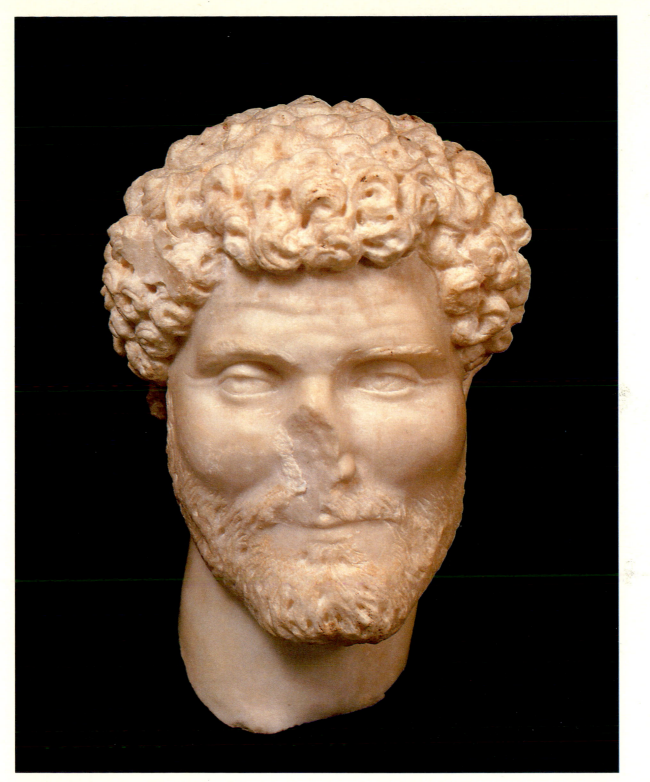

Portrait of a man – Rome (cat. no. 21)

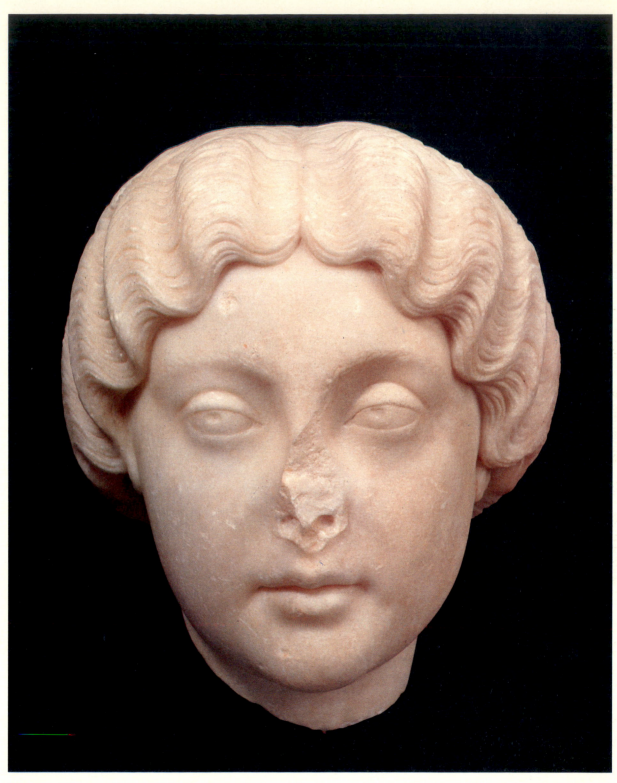

Portrait of Empress Faustina Minor – Rome (cat. no. 19)

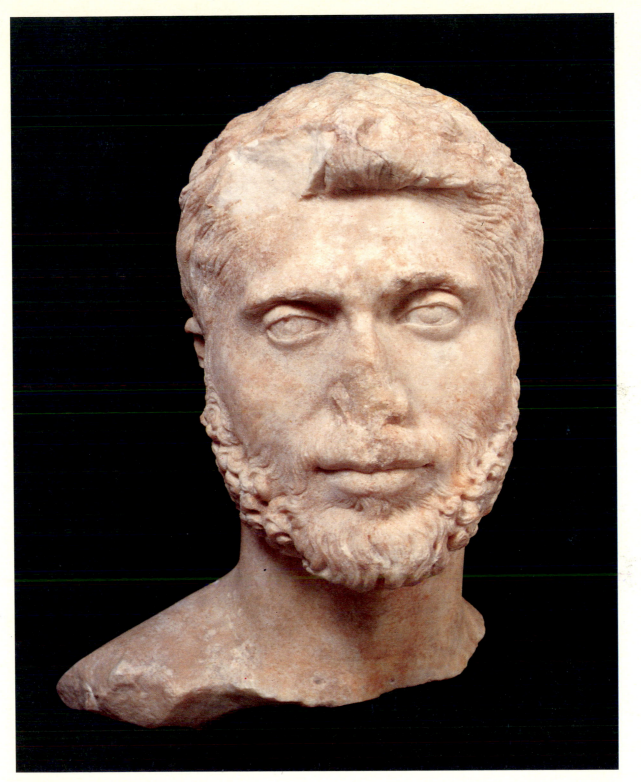

Bust of a man – Rome (cat. no. 9)

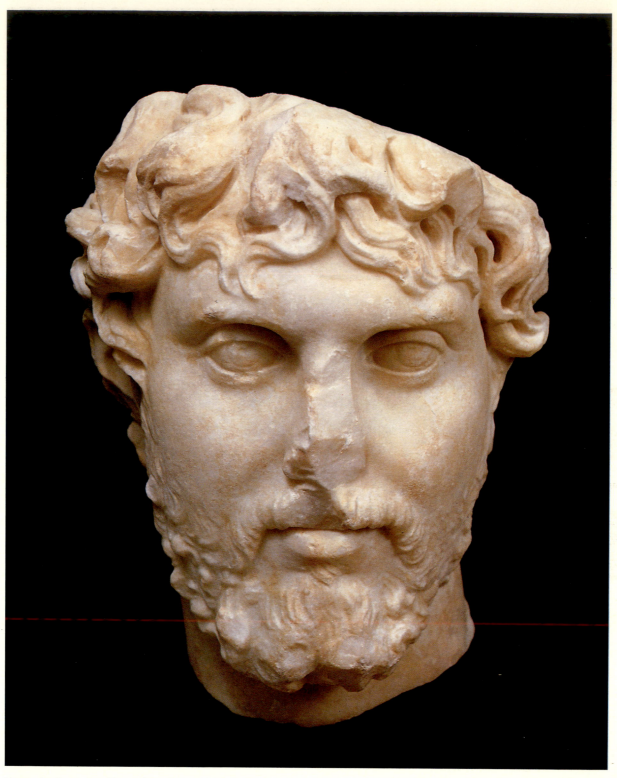

Portrait of a man – Rome (cat. no. 10)

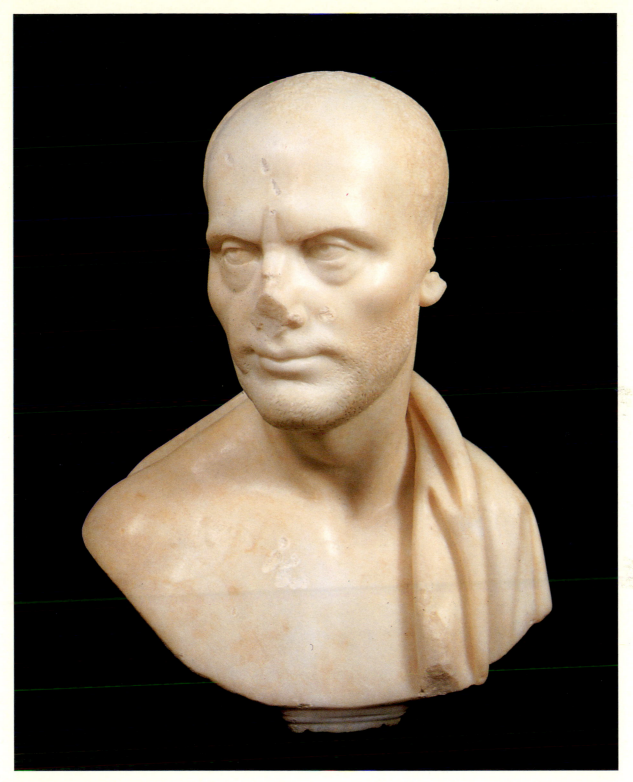

Bust of a man – Rome (cat. no. 11)

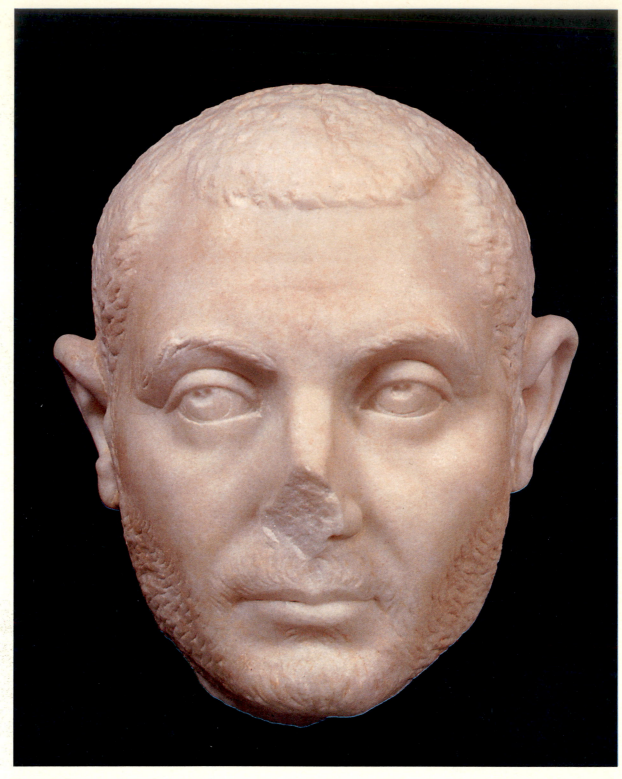

Portrait of a man – Rome (cat. no. 22)

Ius imaginum and Public Portraiture

by Leila Nista

Vitruvius, in his analysis of the main aspects of architectural activity (I, 3, 1), points out how *civitas* is an urban structure for a community of citizens, whose requirements of social life - *opportunitas* - characterize the most peculiar forms of it. Therefore, if *opportunitas* defines the characters of *defensio* and *religio,* it also undoubtedly conditions the origin and the forms of one of the typologies most intimately connected with the social sphere: the portrait in its private and public function.

What, according to the later terminology of Sigonius is commonly defined as *ius imaginum,* is probably the starting point for the first of the two functions, meaning by *ius* the set of rules the *consuetudo* makes object of law and by *imaginum* the numerous expressions of the portrait. As in fact *Cicero* reports (CIC. *Pro. Rab. Post.* 7.16; CIC. *De lege agr.* 2.1.1.; CIC. *Verr.* 2.5.14.36), in about 70 B.C. those who had at least held the curule aedility were awarded the *ius imaginis, ius* confirming the privilege of allowing their descendants to keep their death-mask *(imago)* together with those of the other ancestors (VAL. MAX. 5, 8, 3; SALL. Iug. 4, 5-6), exhibited, privately in the vestibule of the house, and publicly in the *pompa* of the *gentilicia funera* (POLIB., *Hist.* VII, 53). In this way, the object of *ius* became part of the ancestors' cult and of their eternal memory, while their descendants, by such a keeping (POLIB. *Hist. VII, 53-54),* inherited glory, *virtus* and fame. Such a privilege, which could be revoked by the *abolitio memoriae ("Bildnisverbot")* and then by the *abolitio imaginis,* through the link with the *imagines* and consequently with the memory of the other members of *gens,* and diluted the importance of individual characters, blending in the *memoria* of the clan. In this way, the group praised itself at the same time, and, through the fusion of the world of the dead with that of the living, fusion based on the connection of memory (VAL. MAX., 5, 8, 3) and exemplified by common burial rites, it reinforced the connective tissue of the *gens,* through the concept of *utilitas.*

According to such data, we can correctly define the *imagines maiorum* in one respect, as relevant to the *ius privatum* and in another, as connected with the *ius publicum,* since both are signs of honor for magistrate. Consequently the peculiar concept of "posthumous" portraiture could have been the starting point even for the spread of portraits and commemorative statues of ancestors, set in public places. It was not by chance, that the consul *Appius Claudius* placed in the temple of *Bellona* the *imagines clipeatae* of those among his own ancestors (PLIN. *N.H.* 35.3.12) who had held curule offices, probably setting reproductions of the same effigies kept in the vestibule of his own house and *Cicero,* in the trial against *Verres* (CIC. *Verr.* II 4, 81), requested that

33

not only the *Cornelii,* but the whole republic, had the right to enjoy the portrait of *Scipio.*

As for the identification of the social class object of such a *ius,* at least in origin, the patrician order had probably been the only one to enjoy it; it was in fact the only class organized in *gentes* (LIV. 10, 8, 9) and consequently the only one holding those *gentilicia funera,* the original social and temporal space of the *ius imaginum;* the *maiores* Pliny is talking about (*N.H.* 35.2.2.6) as a legal subject, must therefore identify themselves with the patrician order of the fourth century B.C., a time connected not only with the name of *Lisistratus,* presumed inventor of the technique of casting, but above all with precise historical events. As the laws of *Liciniae Sextiae* in 365 B.C. ratified the equalization between patricians and plebeians, a deep class rivalry is likely to have been produced. The patricians, who were downgraded more formally than substantially, remained in fact the ruling class of typically hereditary extraction (until 172 B.C.), probably had wanted to continue distinguishing themselves ideologically. Hence the necessity of acquisition and preservation of the portraits of those ancestors the newcomers were lacking, notwithstanding the attempts of *contaminatio* of the *lex Canuleia,* and hence the necessity of the confirmation of a hereditary transmission of glory, virtue, social status and therefore political power. Obviously, in the course of time this barrier is gradually overcome, and if the beginning of this phase is first apparent at the end of the Punic Wars, the most remarkable impact with a diversified reality comes during the period following the *Gracchi.*

At this time, the accumulation of capital in the hands of a few people brings about the progressive success not only of the family group, but also and above all the individual, who is extolled for his *pecunia.* So, these *homines novi* hold more and more political offices and not by chance *Cicero,* one of the most famous even if least rich among them, elected curule aedile in 69 B.C., declares that the *ius imaginis* is among the privileges granted to the *aediles.*

However, more than bringing honor to the person involved, such a privilege undoubtedly confers honor on his descendants, in no way cancelling those "old fame" disparities still existing; for that reason *Cicero* expresses a negative opinion of the commemorative portraits, as a symbol of old social injustices (CIC. *Pro. Arch.* 12.30).

Consequently, in this period the portrait aims at counteracting the original concept of posthumous portraiture and at preferring the effigy of living personalities, as a contemporary moment of *res publica* life. So, if on the one hand, *Cicero* does not hesitate to have his portrait sculpted frequently, on the other, the idea of *nobilitas* is altered, from the notion of inherited glories to the possession of *virtus,* as *Marius* states, or of *animus,* as *Seneca* points out (SEN. *Ep.* 44.5), making *Tacitus* underline the lack of *imagines* even at *Germanicus'* funeral (TAC. *Ann.* 2.73.1).

The phenomenon becomes more remarkable during the age of

Caesar (DIO CASS. 44. 4-5; APPIAN. *Bel. civ.* 2.16.106), as result of a pressing personality cult, established in the Augustan Age, which involved individual participation in the *princeps' imperium*.

From the beginning, the confirmation of this sign of honor was probably the object of a juridical regulation which, through a *populi aut senatus sententia*, ratified its legitimacy.

The preponderance of the state was in fact so evident, that it invalidated the concept of property for the erected statue, even for that private citizen who had raised it at his own expenses. In this case in fact, the statue became *ornamenta rei publicae* and therefore unmovable, even if it was not *decretae*, that is belonging to the state and under its care, just as the works of private property but of public fruition, were the object of *ius publicum*, because *res quasi publicatae*.

Therefore, statues erected by the *viri triumphali* became more and more numerous in the sanctuaries, areas outside the *populi aut senatus sententia*, while the public administration placed statues, codified in precise typological formulas, in the theaters, in the basilicas and in the same sites which were the object of the honored citizen's munificence. We have therefore *effiges nudi*, togate statues, and equestrian statues, according to the example of the statue of Silla (APP. *B.C.* 1, 97) and the golden *equus* of *Octavianus* (VELLEIO PAT. 2, 61, 3).

"Res est publica Caesar" (Ov. Tristia, 4.4.15): The preponderance of the Imperial Image

As in consequence of the occurred reappraisal of the *ius imaginum* as a symbol of the clan and of the extolling of individual uniqueness, the first century B.C. lays the foundation for the ensuing success of the imperial image, which little by little prevails over the public representation of the private citizen.

Moreover, it is evident how even in the second century B.C., the Punic and Macedonian Wars contribute to the birth of the ideology of the *imperator*, having necessarily created the role of the man who commanded the army for a long time. So, if *Sulla*, who defines himself as *felix*, (protected by the gods), is the first one to receive divine honors, and if *Cicero* – in agreement with *Scipio* the African's thought – states that immortality and deification are only for those who have served their own country, it is with the *senatus consultum* of 44 B.C. that public images of *Caesar* are ratified. In such a way, the initial ideology of triumph develops in the theology of victory, in order to become the fundamental core of the imperial cult after *Actium*, when the *princeps* becomes *res publica* par excellence. It is just because of the imperial cult and its

promotional value that, from the beginning of the principate we notice a progressive iconographic diffusion of the imperial effigy and an incessant decrease of the public image of the private citizen.

So, if in the Augustan Age one can still find in some *municipia* the dedication of "family galleries", in which by means of iconic statues placed side by side and representing the honored citizen's relations, indirect praise to the person himself, with the continuation of the principate, the galleries of the Julio-Claudian dynasty are those widespread both in Italy and abroad.

So, from Sulci to Leptis, the central power more or less suggests to local governing authorities the possibility and necessity of dedicating iconic statues, which glorify imperial succession; consequently the cult of the dynasty is even visually established in the main squares of the various towns, also by making use of republic iconographical traditions, such as the custom of dedicating in temples (PL. *N.H.* XXXV, 12) *imagines* of famous ancestors, whose life has become part of the *res publica* (CIC. *Verr.* II 4, 81).

The statue of the *Divus Augustus* is frequently the centerpiece of the Julio-Claudian gallery, mighty, no longer alive and therefore godlike, indirectly confirming the power of his successor, whose charismatic nature is however keenly underlined during the Age of *Claudius* in the statue of the living emperor. In this case however, it is not the imperial *imago* that represents affirmation of cult, but the context in which it is placed and its more or less direct connection with the *simulacrum deorum*; it is therefore the statue of the *divus* dead emperor, that incorporates the image of the living emperor in its halo of sacredness.

So, by means of *permixio* to the *deorum simulacra*, the imperial statue becomes *simulacrum* and if *Tiberius statuas atque imagines permisit ea sola condicione, ne inter simulacra deorum, sed inter ornamentis aedium ponerentur* (SUET. *Tib.* XXVI, 3), *Caligula* tries to insert ἀνδριάτες in the temple of Jerusalem (FLAV. *b. Iud.* II, 184) and the εἰκὼν χρυσῆ, that appears in the *Acta Martyrum* among the statues of cult, is nothing but the emperor's image.

The *consecutio* between the concept of posthumous portraiture and the object of divine worship – *consecutio* later surpassed in the contemporaneousness of the *dominus ac deus* of the fourth century A.D. – is also evident in the pratice of the rite, which never offers explicit sacrifices to the living emperor, but to his *numen* or his *genius* and, from 7-6 B.C. to his *Lares*. The information given by *Cassius Dio* (LIX 26, 5; 28, 4), who reports that in about 40 B.C. *Caligula* planned his progressive deification by placing his own golden statue in a temple dedicated to himself and erected in the *capitolium*, was an exceptional case, in particular for the type of material he was citing. In fact in Rome in the first century A.D., the only golden statue we know of, apart from those of *Nero* and *Domitianus*, is probably the statue erected to the dead *Britannicus*, while a special case is the golden statue of *Galba*, which was not

inserted in a temple, in the *forum*, or in the *curia*, but in the *castra pretoria* (*sacellum* of the imperial insigna?).

The use of precious metals for imperial statues seems to be more frequent during the second and third century A.D., when it is attested for *Commodus, Didius Iulianius, Caracalla*, but not for *Marcus Aurelius, Faustina* or *Claudius* II the Gothic. On the contrary, *imagines* in the form of golden and silver busts like the ones found in *Aventicum* or Marengo, can be dedicated without distinction to living or dead emperors. Golden *imagines* are in fact attested for *Caligula, Macrinus, Marcellus, Augustus, Faustina, Marcus Aurelius* (silver *imagines* in the temple of *Venus and Roma*), *Annius Verus* and *Pertinax*.

The connection of the imperial image with the sphere of *sacrum* is ratified through the *consecratio*, juridical means which allow the passage from the *ius umanum* to the *ius divinum*. Such an act, mostly performed by an assigned official, or by the *pontifex*, transforming the imperial statue in *res sacra*, also protects it juridically from the *crimen maiestatis*, through the *lex Julia maiestatis*. Consequently the sacred image protected by the law, spreads in the empire and "imperial families" are newly reproposed according to genealogical lineage, from the Antonine age, to Leptis Magna, to Bulla Regia, perhaps to Timgad, until the middle of the III century A.D., as a synthesis of the continuance, stability and therefore "succession" of the imperial concept; finally, with the tetrarchic groups of Venice, the object of the representation is no longer the succession of the *familia*, but the geographic unity of the empire.

As for the possibility that, in the Imperial Age private citizens could benefit by the erection of commemorative statues on public property, it is clear how, since the first century A.D., the *princeps* had, on one hand progressively limited the right to such a honor and, on the other, arrogated to themselves the largeness of the benefit. In such a way, the privilege was more or less removed from the senatorial nobility's authority, whose role of control therefore proved to be decisive only occasionally. So, it is in the *forum* of *Augustus* that they bring about the passage from the *viri triumphali* to the *summi viri* and if *Tiberius* reduces the number of commemorative statues dedicated to him (SUET. *Tib.* 26, 1), indirectly suggesting to the Senate a greater moderation in permits to private citizens, and *Caligula* forbids completely the placing of *usquam statuam aut imaginem* without his permission (SUET. *Caius* 34, 2-4), it is only with *Claudius*, that such an authority is again delegated to the senate (CASSIUS DIO 60, 25, 2).

The alternation shows therefore how in the first century A.D., the privilege of having a commemorative statue for that private citizen who had distinguished himself in the *res publica* was still largely used, while the settlement of the senatorial or imperial authority that ratified its legitimate character was the disputed element. At this time, the triumphal statues of private citizens, perfectly reliant in their typology on the Augustan concept of the *ornamenta triumphalia*, were in fact numerous.

The category is occasionally appealed to in the second century A.D., when even if the *procurator monument[or]um [statuarum?] imaginum* was attested with *Antoninus Pius* and the *[adi]utor rat(ionis) stat(uarum)* with *Marcus Aurelius*, the statues are mostly legitimate only if posthumous. By this time in fact, the previous monarchical experiences being codified once and for all, the *optimus princeps* only seldom calls himself *primus inter pares* and even if he allows the raising of numerous statues, as in the age of *Marcus Aurelius*, he exercises this power as an instrument of rewarding honored citizens. Finally, evidences of permits for public statues are undoubtedly less frequent in the third and fourth century A.D., when they are reserved for the group subject of *ius*.

Private Portraiture: Public Value and Ideological Purposes

In the analysis of the characteristics of private portraiture, private because they are placed in a private context – the *domus* – and therefore the juridical object of *ius privatum*, it is interesting to examine the public value in this category and its heterogeneous applications. The origin of private portraiture is likely to be connected, from one side, to the acquisition and conservation of the *imagines maiorum* by the *gens*, and from the other, to be iconographically related to the tradition already noticed in hellenistic houses – like *Cleopatra's* in *Delos* – of exhibiting the portraits of the owners of the house itself in the vestibule.

The public value, partly identifiable in the choice of *atrium*, is clearly in similar examples always within the *domus* limits, but of a more intrinsically honorary nature. That is the case of statues and portraits dedicated from freedmen, slaves or clients to the owner's *genius* or to his ancestors (PL. *Nat.* 34, 17), such as in the house of *L. Caecilius Giocundus*, or of representation of characters strictly connected to the homeowner's social life, as in the case of the statue of *P. Clodius* in *Cicero's* house.

On the other hand, even funerary examples like that of *M. Aquilius Regulus*, who, on his plot of land dedicated a statue to his prematurely deceased son, have a partially public function (PLIN. *epist.* 4,7).

The galleries of portraits of Greek and Roman intellectuals are instead relevant to the cultural life of the client and therefore more placeable in his public sphere, as in the finds of the Papyri Villa at *Herculaneum*, of that of *Volusi Saturnini* at *Lucus Feroniae* and that at Genazzano. Such connections, even if they sometimes satisfy pure decorative requirements of literary origin and unquestionable purposes of library ornament (PLIN. *espist.* 4.28), according to a hellenistic tradition (ISID. *De origin*, VI, 5; STRAB. XVII, I.8), above all had to evoke the at-

mosphere of philosophic debate (CIC. *ad Atticum* 1, 8, 2; 1, 9, 2) and implicitly suggest to the visitor the cultural habitat in which to insert the owner of the house. This is the ideological aim, which is fulfilled also through the inclusion in the family *lararium* of thinkers' portraits as examples of moral life and therefore "ancestors of knowledge". That is the case of Demosthenes' bust, placed among the *imagines maiorum* of *M. Brutus* (CIC. *orat. 110*), or that of *Socrates* and *Plato* kept by *Cato* (SEN. *epist.* 64, 9-10), and of *Apollonius* of *Tyana*, placed among the *effiges maiorum* of *Severus Alexander* (*Sev. Alex.* 29, 2).

The portraits of Roman rhetoricians and orators were also numerous, and therefore the images of *Ennius* (CIC. *Tusc.* 1, 15, 34), *Vergilius* (PLIN. *epist.* 3, 7, 8), *Livius* (SUET. *Calig.* 34) and *Cicero* (LAMPRID. *Alex. Sev.* 31, 4) are very common.

The portraits of *Scipio, Cato* or *Brutus* (PLIN. *epist.* 1, 17) have instead a clearly political value, symbolic of ancient Roman ideals, or those of the Gracchi (PLUT. *TG.* 18, 2) and of *L. Apuleius Saturninus* (CIC. *Rab. perd.* 24-25), or of *Marius, Sulla, Pompeius, Caesar*, revealing the political choices of the client. The imperial portraits found in a private context had similar value, representing the loyalties and the *pietas* of the *pater familias* to the central power, if they were dedicated by him, or revealing his relationship with the imperial family, if they were given to him (PLIN. *epist.* X, 8; cf. the seated statues of *Livia* and *Tiberius*, from a villa near *Paestum*; the group of bronze statues, probably coming from a *domus* in Rome; the statues of Vespasian and *Iulia Titi* in the villa of *Plautius Lateranus*).

We must finally point out that portraits and imperial statues could find a place even in private libraries, not *"quasi Caesaris, sed quasi rhetori"*, according to a phenomenon that, on the other hand, is also detectable later. That is the case of the library of Gregory the Great, where rhetoricians, philosophers and emperors are substituted by the Fathers of the Church.

Unless otherwise noted, the abbreviations are those use in Museo Nazionale Romano, Le Sculture I, 9, 1.

Last twenty years of the first century B.C.
White marble; h. 37 cm.
Rome: from the area between via XX Settembre and via delle Finanze - 1907
Inv. n. 38997

The nose and the right ear are missing; it was probably inserted in a bust, or in a statue, as suggested by the neck, which, ending with a small part of breast, appears in the classical "pan di zucchero" form and above all, the sharp oblique cut, that shows how the left shoulder must have been covered with an edge of the mantle.

The portrait was found in 1907, in the area between via XX Settembre and via delle Finanze during the excavation for the building of the Ministry of Agriculture (1907-1914), that revealed a length of Servian Walls, an archaic tomb and late-republican tombs, early imperial finds with structures in *opus reticulatum, opus latericium, opus mixtum*. The material found in the area was plentiful and varied; it is represented, both by the numerous elements of architectural and ornamental decoration (invv. 38999-39012), that make us suppose the existence of a sacred area (as on the other hand, we could infer from the find of the nearby votive offerings of S. Maria della Vittoria), by some pottery relating to the archaic graveyard (invv. nn. 39006/1-8) and by numerous marble fragments (invv. nn. 38998, 39040/39068, 39164) among which is a head of *Hermes* (inv. n. 39166). In this context we can also insert the portrait of the Museo Nazionale Romano, which has been so far wrongly connected with the necropolis of S. Susanna, but that we must associate with the above-mentioned structures, whose vicinity with the necropolis has probably caused the mistake on the origin of the piece. It seems more natural to connect the portrait with one of the private buildings that characterize the area from the end of the Augustan age, more than with a funerary context and we can suppose that the original typology of the find was that of the naked *effiges*, particularly numerous at that time. The portrait at the Terme could be inserted therefore in that category of honorary statues that, linking the individual features to an ideal body, the muscular tension to the dynamics of expression, are frequently found in villas, temples and *sacella*, as they were areas outside the rules imposed in the *Forum*; in such a way, both the villa and the sanctuary, by means of the exhibition of the *viri triumphali*, became a microcosm of private propaganda: that is the case of "the general" of Munich, of the one at Tivoli, of the *Spada* and of the *Poplicola*.

Bibliography: On the find: D. Vaglieri, *NSc* (1907); *BCom* 519, (1907), 337 ss.; CAR, II, F, 102-106, 143; on the style: S. Adamo Muscettola, *Prospettiva* 28 (1982), 2-16; J.Ch. Balty, *Wiss.Zeit. der Humboldt-Universität zu Berlin*, XXXI, 2/3 (1982), 140; M. Sapelli, *Dagli scavi al Museo*, Venezia 1985, 31-32 (ibid. prec. bibl.); *Mus. Naz. Rom.*, I, 9, 1, R38: M. Sapelli.

L.N.

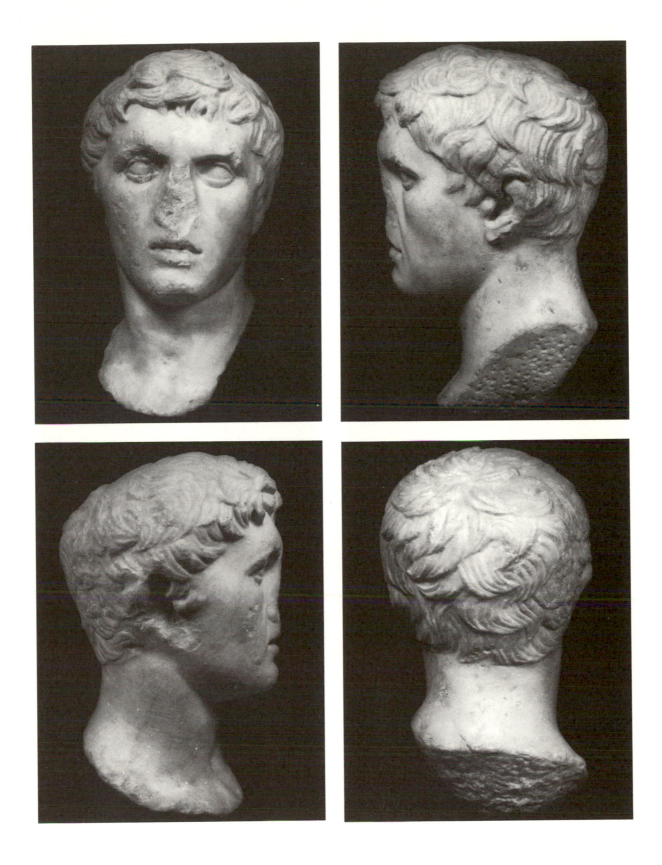

2. PORTRAIT OF A MAN

Middle of the first century B.C.
White marble h. 35 cm.
Palestrina - 1934
Inv. n. 114759

The portrait has chips on the chin, on the lips, on the tip of the nose, on the lower edge of the bust.

3. PORTRAIT OF A WOMAN

Augustan age
White marble; h. 33 cm.
Palestrina - 1938
Inv. n. 124500

A fragment of the *nodus* is missing and there are some chips on the nose.

4. PORTRAIT OF A WOMAN

End of the first century - beginning of the second century A.D.
White marble; h. 31 cm.
Palestrina - 1939
Inv. n. 124474

The nose and great deal of the ears are missing.

In its collection of sculptures, the Museo Nazionale Romano boasts eight marble portraits (invv. nn. 115217; 114759; 124471; 114758; 124471; 124500; 103401; 124474) covering a period from the first century B.C. to the beginning of the second century A.D., all of them characterized by a common but generic origin, that is, Palestrina. The importance of the number and a certain analogy of technique, connected with the presence in the Museum of Palestrina itself and in other Museums, of an equally considerable number of portraits, make us presume the existence of a local workshop in the Latian center. In fact, probably since the middle-republican age, Palestrina has benefited from an iconographic tradition, keenly expressed by heterogeneous canons: that is the case of the limestone women's busts, used as emblems in the local necropolis and dated from the middle of the fourth century to the beginning of the first century B.C., clear examples of an iconographic theorization among the most ancient in the Latium. An evolutionary phase can be confirmed by the limestone head of the Museum at Palestrina and by the one of the Berlin Museum, until the middle of the republican age exemplified by the marble portraits of the Museo Nazionale Romano. We must not underestimate however, the economic vigor of the area, wealthy since the distant past, as we can suppose from the ancient sources, (LIV. VI, 29, 8) according to which the dictator *Cincinnatus,* after having conquered the center, dedicated a golden crown to *Iuppiter* with the spoils of war. Besides, the presence of a sanctuary must have been a relevant element in the creation of both an important tourist business and all the activities connected with it; not less important must have been the climate enjoyed by the whole Praenestine area, that very soon became a much-sought-after resort (PLIN. *Ep.* V, 6, 45;

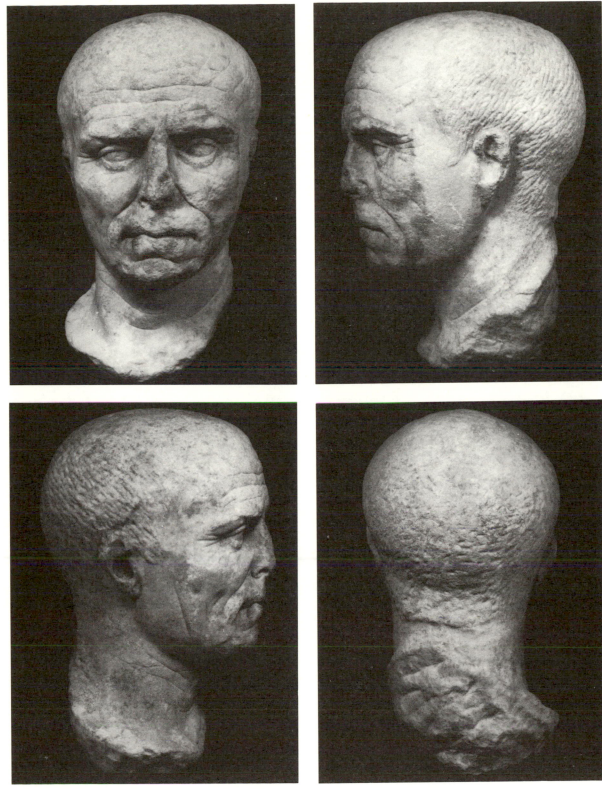

no. 2

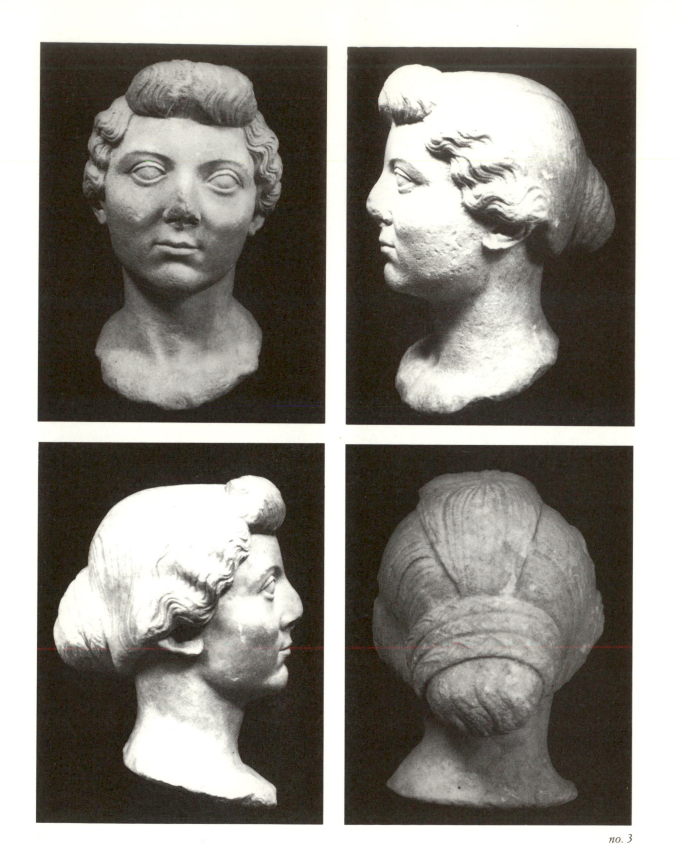

no. 3

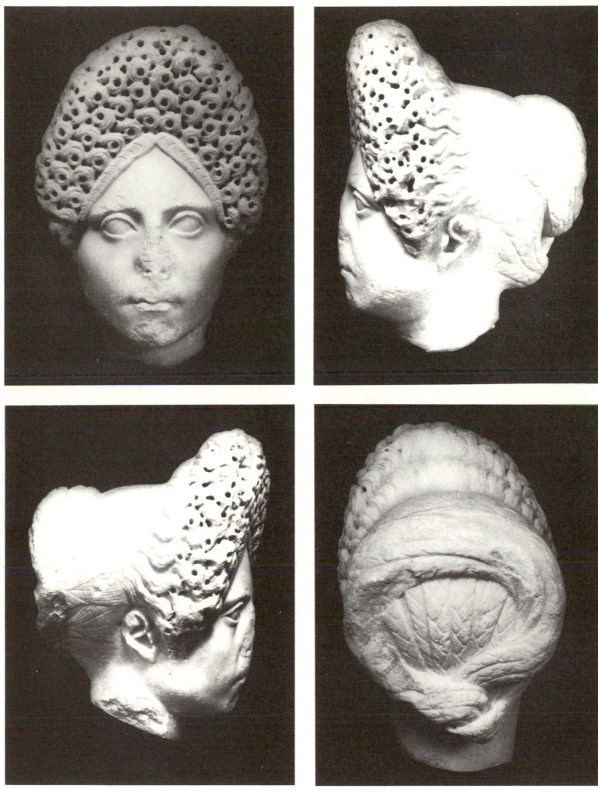

about the *deliciae* of Praeneste cf. Flor. I, 5, 7; Horat. *Ep.* I, 2, 2; Stat. *Silv.* IV, 4, 15) and was considered almost a *suburbium* of Rome for its numerous buildings. In such a context, considering the confirmed presence of a local iconographic tradition, we can possibly suppos the existence of a workshop, probably in the service of the ruling class, originally identified with the *Anicii*, with the *Saufeii*, or with the *Satricarii,* involved in the administration of the sanctuary of *Delos*, or with the *Rupilii*, attested in Asia *Minor*. We can say therefore that the clients conditioned the choice of the pathetic canons of the portrait 115217, variously dated between the second century B.C. and 60 B.C., whose Asian features could be connected with the economic links of the local *negotiatores*; precise iconographic demands have justified the portrait of a man 114559, characterized by that search of the somatic observation wanted by the local municipal class for promotional purposes.

In the same way we can consider the portrait of a man 114758 a figurative synthesis of the individual participation in the *imperium Augusteum*, the portrait of a man 103401 of Julio-Claudian age, the bust of a man 124471, probable trajanic replica of an original dating from 40 B.C. and the portrait of a woman 124474, that may be dated between the end of the first century and the beginning of second century A.D.

The analysis of the portrait of the woman inv. n. 124500 is particularly interesting, because it is a perfect example of the influence exerted by official iconography on private portraiture. Over the years in fact, the head at issue has been identified, sometimes with *Octavia* (28 B.C., death of her son *Marcellus*), sometimes with *Livia* (35 B.C., conferment of the *sacrosantitas*; 30 B.C. battle of *Actium*). Undoubtedly, the portrait recalls the Albani-Bonn typology, both in the hair-style and in some somatic features, such as the almond-shaped eye and the upper lip slightly protruding compared to the lower one. Moreover, the face is much larger than normal and does not get smaller near the temples, while in a general flattening of the features, both the jaw-bone and the chin are notably marked, in a persistence of realistic connotations going beyond the idealization, a coefficient peculiar of the official portaiture of that time.

On the grounds of these formulas, we can therefore propose to insert the portrait at the Terme in the context of private clients, extremely conditioned by the official canons and almost to the limits of the identification with the public personalities of the time.

Bibliography: On the area and its iconographic tradition: A. Giuliano, *RM* 60-61 (1953-54), 172-183; G. Bodei Giglioni, *Rivista Storica Italiana* (1977), 33-76; P. Pensabene, *Arch. Cl.* XXXV (1983), 288-296; on the local workshop: Felletti Maj, *Ritratti,* n. 59; no. 66; H. Bartels, *Studien zum Frauenporträt der augusteischen Zeit,* (München 1963), 34; P. Pensabene, *Miscellanea Archaeologica Tobias Dohrn dedicata,* (Roma 1982), 86 ss.; on the portrait inv. n. 114759: *Mus. Naz. Rom.*, I, 9, 1, R 59: E. Ghisellini (ibid. prec. bibl.); on the portrait inv. n. 124500: N. de Chaisemartin, *Antiquités africaines* 19 (1983), 40 ss. ; *Mus. Naz. Rom.*, I, 9, 1, R 81: L. Nista (ibid. prec. bibl.); on the portrait inv. n. 124474: *Mus. Naz. Rom.* I, 9, 1, R 160: A.A. Amadio (ibid. prec. bibl.).

L.N.

5. PORTRAIT OF DRUSUS MINOR

From the end of the age of *Tiberius* to the age of *Caligula*
White marble; h. 37 cm.
Mentana: area of the *Forum* - 1949
Inv. n. 125711

The portrait's state of preservation is good, only the tip of the nose is chipped. The back of the skull and the neck, are just rough-hewed; the portrait was probably made for insertion – *capite velato* – in a togate statue.

6. PORTRAIT OF GERMANICUS

From the end of the age of *Tiberius* to the age of *Caligula*
White marble; h. 38 cm.
Mentana: area of the *Forum* - 1949
Inv. n. 125712

The portrait's state of preservation is extremely good; only the tip of the nose is chipped. The "pan di zucchero" cut of the breast suggests the insertion of the head in an iconic statue.

7. BUST OF A WOMAN

From the age of *Tiberius* to the age of *Caligula*
White marble; h. 44 cm.
Mentana: area of the *Forum* - 1949
Inv. n. 125713

The bust's state of preservation is excellent; only the tip of the nose is chipped. The head, characterized by hair parted on the brow, gathered into four plaits and worn on the nape in a long *chignon*, is adorned with a ribbon crowning it and hanging down over the shoulders (*infula?*). In the forehead, we can see eleven holes, where a metal crown might have been inserted.

The two portraits of men, together with the bust of the woman, were found in 1949, near the Forum of *Nomentum*. Their good state of preservation allowed both a certain identification of *Drusus Minor*'s effigy, derived by a pattern dated between 14 and 16 A.D. and that of *Germanicus*, variously connected either with the *Leptis-typus*, or with the *Adoptiontypus*, but did not allow the identification of the woman. Being in fact commonly interpreted as a portrait of a private woman, it has recently been associated both with the iconography of *Livia (sacerdos divi Augusti?* DIO. 56, 46, 1; VELL. 2, 55, 3, cf. group of Medina Sidonia), and with that of *Antonia Minor* with *corona spicea* and as *sacerdos divi augusti*; the latter connection should be linked to the anecdote that *Cassius Dio* has handed down, remembering how *Caligula* had conferred on her such a sacerdocy and would be inserted well in the iconography attested by the contemporary monetary series, called *sacerdos*.
However, apart from the identification of the female personality, be it really *Antonia Minor*, as we could suppose by some peculiarities, or be it a private woman perhaps connected with the imperial cult, as the absence of realistic representations in the official production of *Antonia Minor* could denote, without doubt the three portraits form a group of *imagines* officially exhibited in some building of the *Forum* at *Nomentum*,

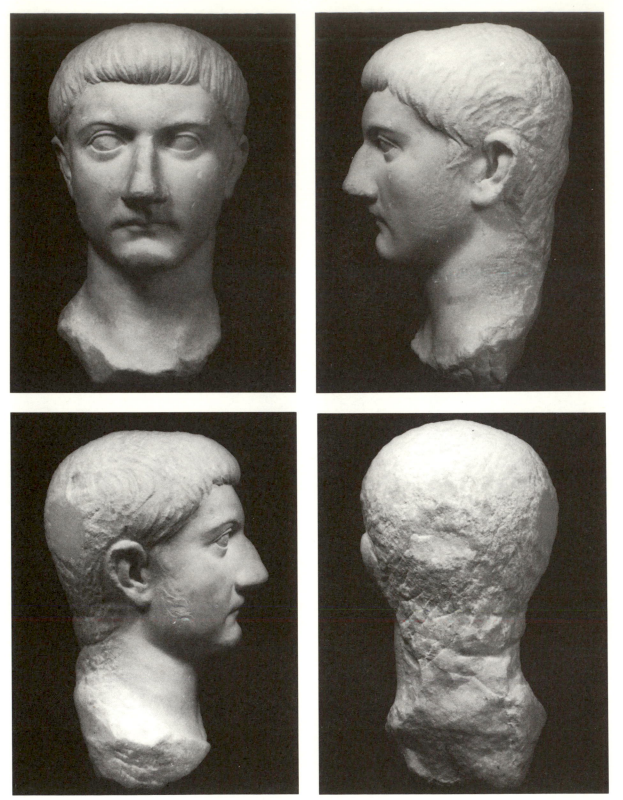

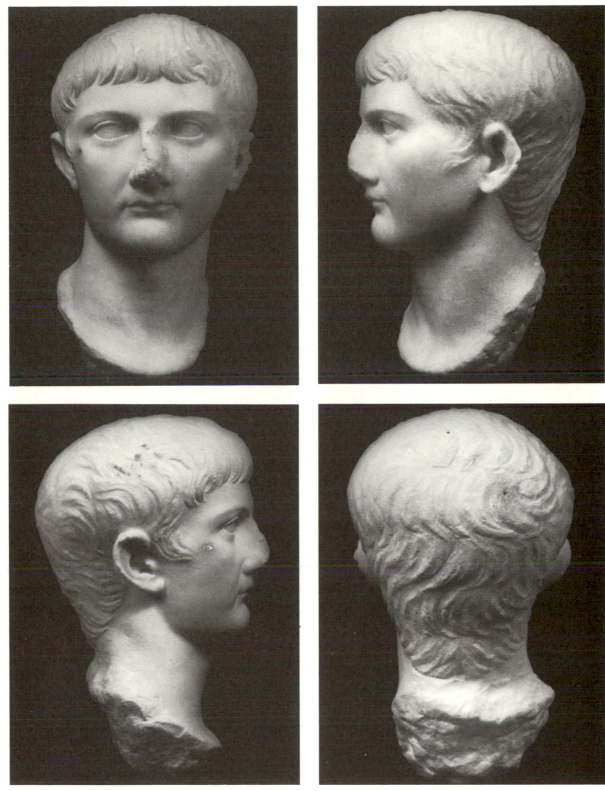

no. 6

the ones representing a man, as statues, the female portrait, as a separate bust. The group, set against this background, similar in the fragmentary nature of the data we have on its find with the Priverno and Avignon cycles, can be connected perfectly with that typical phenomenon of the first fifty years of the first century A.D., represented by the so-called Julio-Claudian "galleries". These "galleries", that became widespread in Italy and abroad, were always placed in the most important sites of the town, in a perfect correspondence between iconographic form and building typology, represented by the adoption of the apsidal architectural motif.

In such a context, the *Forum,* with its buildings belonging to the state or to the town administration, is undoubtedly one of the best backgrounds for extolling the continuity of the dynasty, in alluding to the absolutely honest application of that *ius publicum,* which the imperial figure directly vouched for. At the same time, the multiple templar structures inside, allowed the contemporaneous insertion of the same imperial figure even in the sphere of the *sacrum.* Cycles are thus attested by the basilica of Velleia, Rusellae, Thera, Sabratha, Corinth, by the so-called basilica of Otricoli, from the *curia* of Timgad, by the *Augusteum* of Tivoli, Miseno, Centuripe, while on the imposing group of Brescia, traditionally identified with the *capitolium* of the town, they have put forward the hypothesis, that it could be a honorary building similar to that of Miseno; a group of imperial statues is also attested by the *capitolium* of Gigthis. Moreover we can point out how the group of *imagines* from *Nomentum* might have completed or substituted previous *imagines,* as we can suppose by the find (1833) of a dedication to *Germanicus* (CIL XIV, 3942 = ILS, 1887). Finally, we must draw attention to a further male portrait of fine workmanship and of private property, which came from *Nomentum* and must surely have been inserted in a statue, as the cut of the neck indicates. The portrait previously identified as representing *Gaius Caesar,* seems undoubtedly to be connected with the Julio-Claudian dynasty and originally it might have been exhibited in a public place. It is still to be verified if it can be connected with the other official portraits from Mentana, or perhaps with the property that originally *T. Pomponius Atticus* owned in the area of *Nomentum.*

Bibliography: On the area of the find: C. Pala, *Nomentum. Forma Italiae.* XXII, (Roma 1976) p. 31 ss.; on the typological analysis: A. Andreae, *AA* (1957), 227 ff.; V. Poulsen, *Claudische Prinzen,* (Baden Baden 1960), 14, no. 10; J. Fink, *Antike und Universalgeschichte. Festschrift H.E. Stier,* (1972), 280, 285; K. Polaschek, *TrZ* 35 (1972), 176, note 135, fig. 10, 6; Kiss, p. 99, figs. 314-315; 119, note 434-435; H. Jucker, *Melanges d'histoire ancienne et d'archeologie offerts a P. Collart,* Lausanne 1976, p. 259, note 115; *Id., JdI* 82 (1977), p. 233, note 116; Fittschen, *Erbach,* 44, note 17, I; 46, note 22; 50 note 9; L. Sensi, *Ann. Lett. Filos. Perugia* XVIII (1980-81), 75-80, pl. X; Massner, 89-91; 92, note 489; G. Dareggi, *BdA* (1982) 29, note 42; D. Hertel, *Untersuchungen zur stil und chronologie des Kaiser und Prinzenporträts von Augustus bis Claudius,* (Bonn 1982), 54ff.; 134; 135; W. Trillmich, *MM* 1984, 184-201; R. Bahnemann, *Hefte-Das archäologische Seminars der Universität Bern,* 9 (1985), 17, note 9; K. Fittschen, *Germanico. La persona, la personalità, il personaggio,* Atti del Convegno (9-11 Maggio 1986), Università degli Studi di Macerata (1987), 39, 205 ff. pl. 19-20; L. Sensi, *ibidem,* 220-227; J. Ch. Balty, *II Conferenza Internazionale sul ritratto* (Roma, sett. 1984) (in press); *Mus. Naz. Rom.* I, 9, 3; B. Di Leo (in press).

L.N.

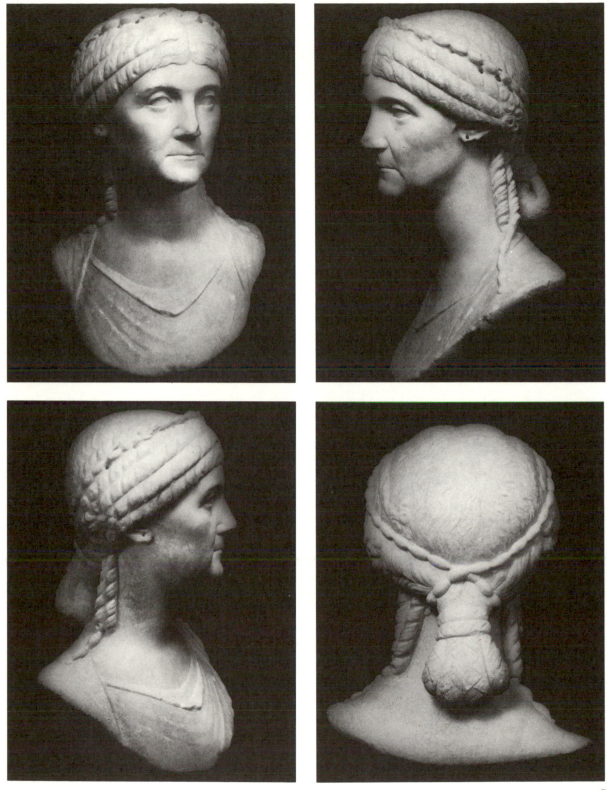

no. 7

Second half of the first century A.D.
White marble; h. 31 cm.
Rome: area of Castelporziano - Capocotta - 1908
Inv. n. 387905

The portrait may be identified with Vespasianus and the incongruities, that can be noted in both sides of the face, must be considered reworkings. In fact, as someone has correctly pointed out, the portrait could have originally represented the face of *Nero*, and have been later modified in the effigy of *Vespasianus*.

The incompleteness of the data about the find of the portrait, is consistent with the general loss of data and materials suffered by the ostiensis and laurentina coast. Since the second Punic War and above all since the late Republic, this coastal strip in fact is the object of a remarkable residential building development, basically brought about by the nearness to Rome, which on the one hand makes easier the development of building structures on the seaside (CIC. *De Oratione* II, 6, 22; VARR. *De re rustica* III, 13, 2-3; MACROB. I, II, 21) and on other assures the presence of a commercial center. From the Augustan era onwards, the phenomenon has taken on more outstanding aspects and the *laurentina* coast is enriched with out-of-town villas, while the little village of *vicus Augustanus*, risen just in that age and existing until Late -Antiquity, is, more than Ostia, the functional center. The above-mentioned building structures concentrate in the coastal strip between Castel Fusano, Castel Porziano and Capocotta, while the whole area is linked to Rome by the road network of the via Ostiensis and the via Laurentina connected with the via Severiana, dating third century A.D. and following an old coast layout. The two villages of Grotta di Piastra and Tor Paterno are the central hinges of this area. The former can be hypothetically connected with the topographical connotations of the villa of *Plinius* the Younger, described by him in a letter to *Gallus* (*Ep.* II, *XVII*); the latter is basically characaterized by the setting up, since the Augustan age (GELLIO X, 2, 2) of an imperial property grown progressively larger, thanks to acquisitions of landed properties (SUET. Aug., 72, I). In the Flavian age, the land takes on a more precise structural connotation (cf. CIL VI, 8583, *T. Claudius Speclator procurator Laurento ad elephantos* and a *Flavius Olimpicus Vilicus de praetorio*), getting finally in the Antonine age the first explicit evidence of the existence of an imperial *praedium* (EROD. I, 12. 2). According to such data, we can possibly connect the portrait at the Terme with one of the above-mentioned building contexts, and hypothetically to the one from Tor Paterno, also for its nearness to the area of Capocotta.

Bibliography: On the find: G. CULTRERA, *NSc* (1908), 472-473, fig. I; on the area: *Castelporziano,* I, 1984, (Roma 1985), (ibid. prec. bibl.); *Castelporziano,* II, 1985-1986, (Roma 1987); on the typological analysis: *Mus. Naz. Rom.*, I, 9, 1, R 145: A.A. AMADIO (ibid. prec. bibl.).

L.N.

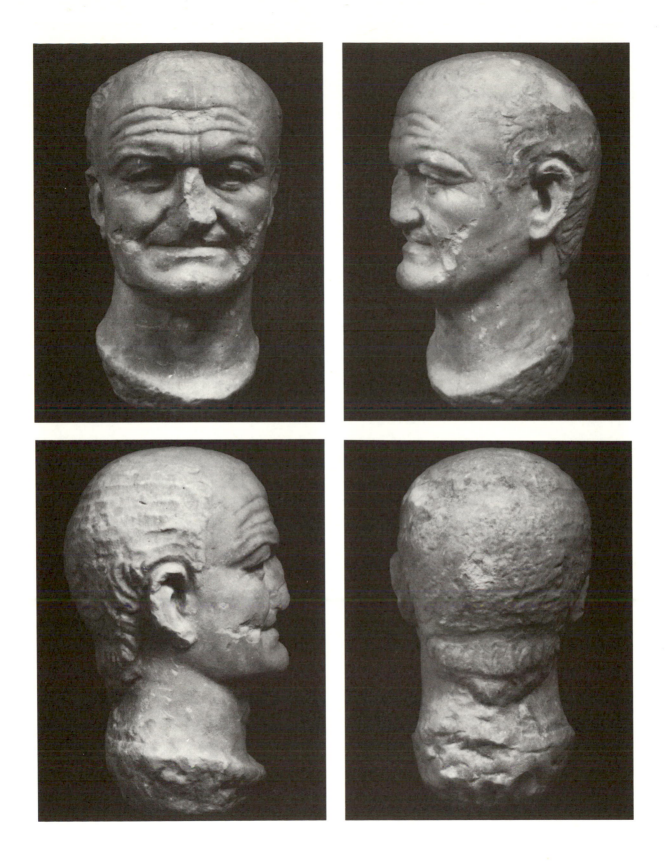

Second half of the second century A.D.
White marble; h. 33 cm.
Rome: Via Cassia, surroundings of Acquatraversa - 1917
Inv. n. 73943

The nose is missing, along with part of the hair and part of the bust, of which only a section of the right shoulder is preserved.

The portrait was found in 1917, in the area of Acquatraversa, a term meaning an estate at the fifth-sixth km. of the Via Cassia, once owned by Ruffo della Scaletta, and that might be connected with the *Tutia amnis* of Livian memory (LIV. XXVI, II). Here, a set of diversified buildings turn up in a long series of diggings for drainage works. Among them, we can remember the ruins of a tomb, probably belonging to a magistrate – as we may conclude from the examination of two fragments of frieze decorated with lictorian *pompa* (invv. nn. 57238-57239), inscribed slabs (invv. nn. 57240-57241) and marble steles (invv. nn. 57242-57243). Also in the same area in 1919, multiple structures (*sacellum* of *Liber Pater?*), were found with baths, private residences, different marble sculptures and numerous funerary settings (invv. nn. 73944/73987), apart from the portrait at issue. Finally, we must not forget how the so-called villa of *L. Verus* attested by the sources (*Hist. Aug. Ver.,* 8) was located in the same area with building structures belonging to a nymphaeum and a cistern provided with a complex system of underground passages traversing the hill, where the whole building was.
According to such data, we can therefore connect the portrait of the Museo Nazionale Romano with one of these structures. Further precise information could be provided only after the present series of researches carried out by the Archeological Service of Rome.

Bibliography: On the find: R. PARIBENI, *NSc* (1923), 394; on the area; G. GATTI, *BCom* (1899-1900), 151-152; A. PASQUI, *NSc* (1911), 37; R. PARIBENI, *NSc* (1919), 283; *Quad AEI* V (1983), 144-145 (ibid. prec. bibl.); on the villa of *L. Verus*: G. LUGLI, *BCom* (1923), 47-62; G. MESSINEO-C. CALCI, *BCom*, (in press); on the style: *Mus. Naz. Rom.* I, 9, 2, R 231: A. CIOFFARELLI (ibid. prec. bibl.).

L.N.

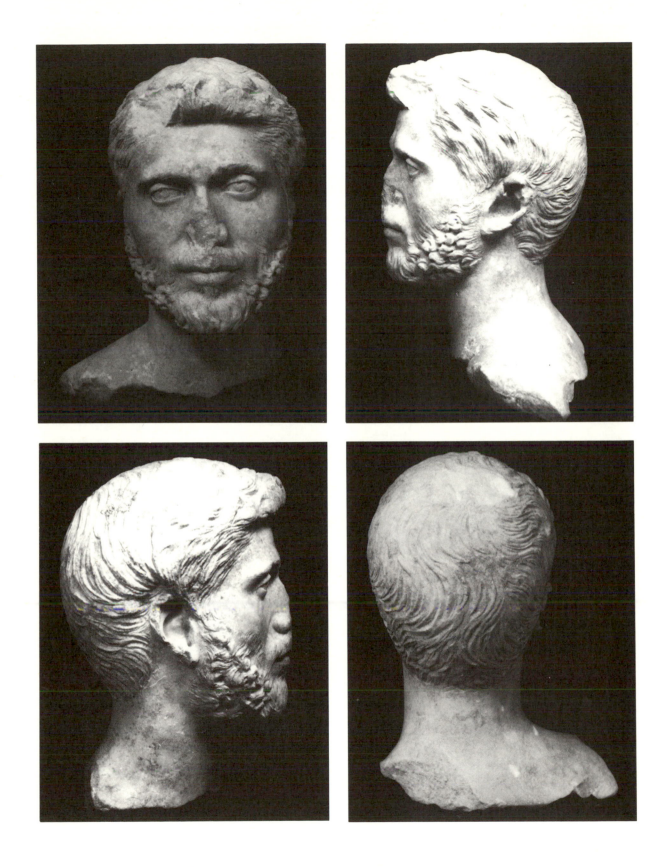

Severan period
White marble; h. 32,5 cm.
Rome: Settizonio - 1888
Inv. n. 204

The nose and the upper lip are missing. The portrait has a big hollow on the back of the head, that in a small part adhered to a surface; the top of the head, perhaps worked separately together with the back, is missing.

The first connection between this portrait and the area of *Settizonium* dates back to 1933; since then, such an origin, attested also by the records of the Archeological Service of Rome, has been simply reported in the data about the sculpture, without being determined farther on. Moreover, numerous aspects concerning not only the nature of the building at issue, but also its exact location, are still unsolved. The description of its erection reads in fact in the *Historia Augusta* (SEV. XIX, 5; XXIV, 3)... *aeditum palatinis aedibus, id est, regium atrium...* and the building – dating about 203 A.D. according to the inscription engraved on the epistyle of the first floor and partly copied by the Anonymous of Einsiedlen (CIL VI, 1032) – was progressively destroyed until 1588-89, when the Pope Sistus V ordered Architect Fontana to clear away its last section remaining in the area of S. Gregorio. Not only its location and orientation are therefore disputed because of its systematic destruction, but also its function, whose numerous interpretations can however be found in the different names it has had both in the literary sources and in the epigraphic materials. It varies in fact from *Septizonium/Septizodium*, a building formed by seven *zonae,* to *Septizodium/Septemzodium* (AMM. MARCELL. XV, 7, 3) a building adorned by seven gods representing the seven planets, to *Septisolium,* a building provided with seven basins, *solium* or water hydrants, in a variety of functional interpretations that, as recently pointed out, can easily coexist in the structure at issue. According to the above-mentioned data, we are unlikely to be able to deduce information about the sculptural decoration of the monument, whose analysis in fact requires the knowledge of the marble materials coming from the excavation of 1933 along via S. Gregorio and now exhibited in the Antiquario Comunale. The connection between the *Septizonium* and the portrait here dealt with, in any case attested even if not determined, induced us to reconsider the portrait stylistically, as it has some unquestionable assonances with the portraiture of the Severan period. In fact, not only a general baroque style and a continuous seeking of coloristic effects condition the appearance of the portrait, but in the structure of the various sections of the face, a slight "family likeness", connects it ideally to the imperial typologies of the same period (cf. the four locks on the forehead, the short beard divided in two and with little tufts under the lower lip, which is small, fleshy and prominent, curving locks on the left temple of the portraits of *Septimus Severus,* such as *Serapis*). Such features, that without doubt exist and therefore we must not underestimate, have been stated as pure hypothesis, that is to say, in anticipation of a more exhaustive analysis, which may or may not support the possibility of inserting the portrait in the sculptural decoration of a building from Severan period.

Bibliography: On the area: J. VERBOGEN, *Acta A Lov.* 21 (1982), 127-140; *QuadAEI* VIII (1987), pp. 57-64 (ibid. prec. bibl.); P. FANCELLI, *Roma e l'antico*, (Roma 1987), 397-398; on the style; *Mus. Naz. Rom.*, I, 9, 2, R 201: L. MARTELLI (ibid. prec. bibl.).

L.N.

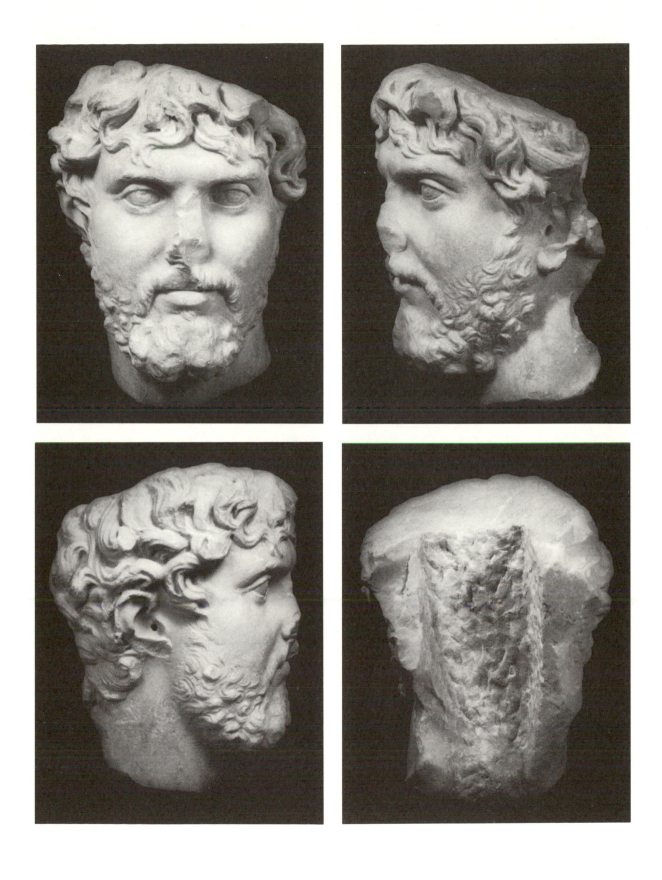

Second quarter of the third century A.D.
White marble; h. 47 cm.
Rome: via Cassia - 1948
Inv. n. 1255600

The tip of the nose and a large part of the left ear are missing

In 1948, during the restoration of a country cottage at Via Cassia antica Km. 11.500, ruins of a roman villa were found out in a plot of land owned by Mr.A. Sansoni. The villa, whose living level was revealed, not only by the presence of attached baths, but also by the kind of flooring used in the different rooms – mosaic with sea-motif, mosaic with geometrical patterns – was probably occupied from the middle of the second century to the end of the fourth century A.D., as some seals found there indicate (CIL VI, I, 846; CIL XV, I, 1559); the villa should have been connected with a second country cottage found recently and located in the immediate vicinity in Via Barbarano Romano (Km. 11.800). As for the bust of the Museo Nazionale Romano – found in a room of the villa together with a portrait of Caracalla (inv. n. 125565 - Museo Nazionale Romano) – it probably belonged to one of the owners of the villa, who undoubtedly wanted to connect his own features with the image of the *homo spiritualis*. The association however is not fortuitous, as the figure of the philosopher, as well as of the rhetorician and the teacher, was connected to the figure of the intellectual, repository of that knowledge, possession of the ruling class since the end of the second century B.C.
Such an ideological identification, that soon became iconographic identity, is made clearer during the third century A.D., when because of the great militarization (already noticeable under *Septimius Severus,* and become well established under *Gallienus*) it is the senatorial class that cultivates the literary *otia* in the villas of the *suburbium*. In such a cultural background it is possible to insert the portrait of the Museo Nazionale Romano, which can be dated from the second quarter of the third century A.D,. both for somatic typologies and stylistic elements.

Bibliography: On the find: D. Faccenna, *NSc* (1948), 276 ss., fig. 6; *id., BCom*, LXXII (1946-48), 79 ff., pl. I; on the area *QuadAEI* V (1983), 143 (ibid. bibl. prec.); on the style: *Mus. Naz. Rom.* I, 9, 1, R 294: A.L. Cesarano (ibid. prec. bibl.).

L.N.

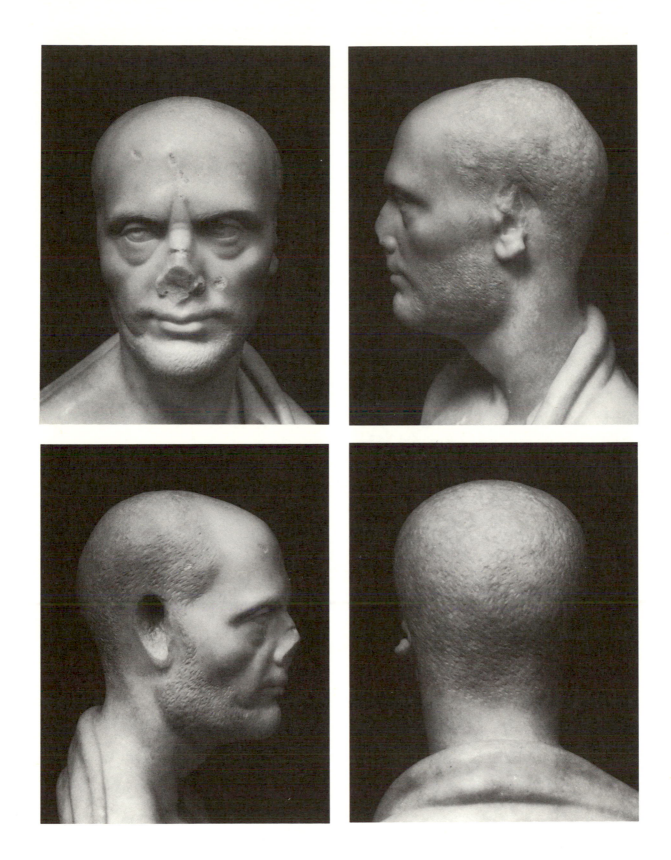

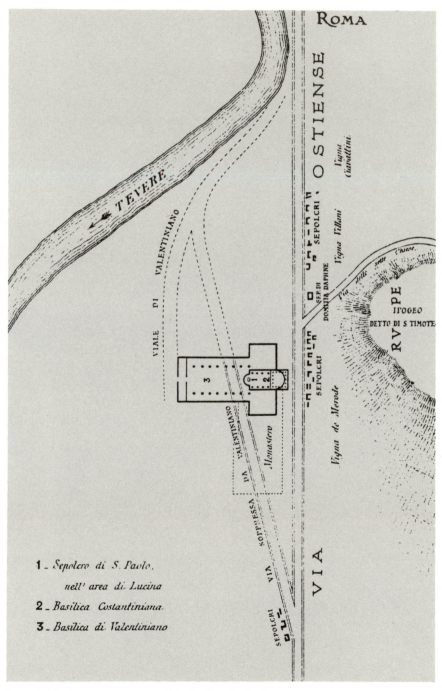

Rome, Via Ostiense, necropolis east of the Basilica of S. Paolo.

Roman Portraits in Religious and Funerary Contexts

by Maxwell L. Anderson

It is the central argument of this exhibition that we have much to learn from the original contexts of ancient portraits, and much to lose when we are deprived of knowledge about such contexts. Some kinds of evidence that have come down to us are nothing more than tantalizing, but we have included whatever information survives about the circumstances of discovery of each portrait in order to give more dimension to the objects and their function in Roman society, and to demonstrate how much would be gained from a fuller knowledge of their original setting. With this as the focus of the exhibition, more conventional questions about Roman portraits will not be asked and answered; the authors have deliberately confined themselves to issues related to the setting of the works, and typological and chronological issues have been set aside.

The propagandistic nature of Roman public portraiture and the commemorative role of honorific portraiture in private homes have stimulated the imagination of chroniclers of Roman civilization from Gibbon to the present. Portraits had other functions in Roman society which are more difficult to assess because of the generally poor preservation of their original contexts. Whereas portrait statues in public fora are easily imagined by the modern observer, since this function of portraiture has changed little since the Roman Empire, and private likenesses are routinely used today in much the same way as in antiquity, adorning the libraries of the well-to-do, other settings in the Roman world do not have such close approximations in contemporary architecture and public spaces.

In Roman antiquity, the religious spaces in which portraiture played an important role included the cavernous temples which had, in the Greek past, an enormous image of a deity. It became common beginning with the deification of Julius Caesar to have statues of Roman leaders figure as a central part of the temple's decoration, as in the statue of the Divine Caesar in the Temple of Venus (DIO CASSIUS, 45.7.1). Some descriptions, in fact, leave in doubt whether certain dedications were religious or secular in intention. Mark Antony had himself represented as Osiris and Dionysos, together with statues of Cleopatra as Selene and Isis (DIO CASSIUS, 50.5.3). We learn from Valerius Maximus that a portrait of Scipio Africanus was placed in the cella of the Temple of Jupiter Optimus Maximus (7.15.1-2). The room for doubt suggests that divisions between secular and religious dedications were not very clearly drawn in the Republic or the Empire. This is in turn a function of the fact that politics and religion were effectively inseparable in Roman society. Appian (CIVIL WARS 2, 102) tells us that in Julius Caesar's temple

to Venus Genetrix, "next to the goddess he placed the beautiful portrait of Cleopatra, which stands there even now."

The colossal statues of the imperial temples have for the most part survived only in ancient desccriptions, and but a few ivory fragments survive which may be linked to the massive gold and ivory (chryselephantine) dedications of the Roman Empire. It is difficult today to visualize the scale of the statues except in certain totalitarian states where images of such magnitude stand to this day. Perhaps the most familiar image of this type surviving from the Roman world is the colossal portrait of the emperor Constantine which rests in the court-yard of the Conservatori Palace in Rome. The head alone measures 2.60 meters in height, so that the statue of the seated emperor would have dwarfed visitors to the Basilica of Constantine. The statue may originally have depicted the emperor Trajan, and have been recut to depict Constantine, a fate which was apparently common to colossal images of Trajan. It was made with a brick core, and the body was fashioned of wood covered by bronze. Apart from the head, the limbs were made of marble as well. The purpose of this statue was to underscore the *auctoritas* of the emperor, but it also served as a central monument to the evangelization of Roman art in the medium of portraiture.

In addition to the abundant portrait statues in public temples were portraits in religious sanctuaries. The portrait of Antinous (no. 15) was discovered in a sanctuary of the Magna Mater at Ostia, and has been shown to bear images of divinities related to the cult of Attis on the headdress. Previously considered portraits within portraits, the busts on Antinous's headress were re-identified by R. Calza from images of Nerva and Trajan to images of Cybele and Attis or related figures in the worship of the cult of Attis. The identities of these small busts were determined by the original location of the portrait in a sanctuary, which cements the portrait's pertinence to the cult. Antinous is accordingly shown as a priest of Attis, as perhaps part of a statue dedicated to the god in the triangular Ostian sanctuary. The existence of similar portraits is well documented; an Antonine portrait of a young man in the guise of Bacchus in the Metropolitan Museum and a comparable portrait in the Uffizi exemplify the use of portraiture for religious ends. During the middle of the second century A.D., a number of foreign cults made their way to Ostia, and portraits were made of priests in the service of each cult.

Cult portraits thus served public and private figures who had themselves commemorated in the costume and guise of worshipers of religions important to them out of true conviction or political expediency. After the drowning of Antinous in A.D. 130 in the Nile, a series of cults were established in the memory of the young Bithynian which led to his commemoration in the image of several gods, including Bacchus and Silvanus.

In addition to traditional religious sanctuaries, other religious set-

tings were also appropriate for commemorations in portraiture. The image of *Faustina Minor* (no. 17) was retrieved in the House of the Vestal Virgins in the Roman Forum along with other portraits of late second and third–century rulers. Although the evidence is far from clear, it would have been appropriate to include a portrait statue of the empress if she had been instrumental in aiding the cult, either through donations or by subsidizing a renovation of part of the *Atrium Vestae.*

There was license enough in the mixture of portraits of private individuals in religous settings to countenance the erection of a statue of a physician, Antonius Musa, adjacent to a statue of Hygeia, the god of health, because the physician was credited with having cured the emperor Augustus of a perilous illness (SUETONIUS, *The Divine Augustus,* 59). Although there may be an analogy here to the later practice of including portraits of donors in painted altarpieces, the juxtaposition of a doctor with the god of health would have been a more brazen linkage, since the statues were very likely no different in size.

Domestic shrines, too, were places suitable for portrait dedications. The lararia, or household shrines, included bronze statuettes of divinities but also of important ancestors, often in the form of small busts. There are also portraits evident in sculpted reliefs, such as that in the Copenhagen Nationalmuseet, showing busts in a cupboard, or a similar relief in the Capitoline Museums. They were probably made of plaster or wax, but images of more precious materials like bronze or marble must have been so displayed as well. Such portraits bring us from the realm of religion into the much larger category of private and public funerary commemorations.

Funerary portraiture is an enigmatic category for the modern observer, since burials after the Renaissance do not normally include an image of the deceased as an integral part of the burial; an inscription and an architectural setting are usually considered sufficient. By contrast, this category of portraiture was deeply important to Roman society from its inception. During the mid second century B.C., Polybios writes of the uses of portraiture in funerary settings and ceremonies (6.53). In particular, he describes the Republican traditions of venerating the deceased in their own household by placing a portrait in a wooden aedicular shrine in a prominent part of the domus. This tradition is, as we shall see, adopted by the less fortunate in underground tomb chambers outside of the city's walls, where painted niches including inscribed information about the deceased are an integral part of the interiors of tomb architecture. Polybios specifies that the funerary portraits set up in private homes are in the form of masks, and much modern speculation has focused on whether these are actual death masks, taken in a mold from the face of the deceased, or mask-like portraits. He continues by recounting that these images were displayed at public sacrifices in order to remind the populace of the achievements and contributions of the elders, and that they were carried as part of a funeral procession in a way

surprising to contemporary sensibilities. The mask commemorating the departed was worn by a member of the procession who closely resembled the honored in stature, and who carried the symbols of a lifetime's contributions: the insignias earned in service of the state. In this cultic fashion, portraiture early on in the history of Roman culture served to honor the memory of the dead in a visible, animated ceremony celebrating personal achievement. It was accordingly in a public spirit that funerary portraiture began, as Pliny later emphasizes (NH 35.6-7). In a fascinating account of the same traditions earlier described by Polybios, Pliny specifies that the ancestral portraits carried in processions were of wax, a perishable medium which would help explain the dearth of evidence from the early Republic. Pliny clarifies the nature of portrait display in the Roman home, noting that in the atrium of the Roman house, it was the custom to place the funerary portrait on separate chests, with the entire geneology represented by wax images suitable for public exhibition on the occasion of the death of the paterfamilias. In some way, the private displays also included a sort of annotated family tree, evidently of painted portraits connected by lines to indicate the lineage of each person so commemorated. Pliny continues by noting that the libraries (archive rooms) of private homes contained scrolls detailing the achievements of the deceased during their lifetimes. He also observes that there were portraits of the deceased displayed around the door lintels of the house.

The uses of funerary portraits from the Republic seem odd to the modern observer because the ritual animation of the dead is a practice we associate with primitive cultures. Yet the superstitious character of Roman society was thoroughly institutionalized, and it would be mistaken to deprive such images of their original totemic significance because of our idolization of Roman rationality.

The burial in columbaria, underground tomb chambers which derive their Latin name from their similarity to dovecotes, took many forms during the Republican period. The coarsest form of commemoration involved the interment of the cremated remains of the deceased in terracotta urns.

Depending upon the social level of the person commemorated and the means at his disposal, the burial also took more elaborate forms, including marble, alabaster, and glass containers for the ashes and bones to be kept, and often consisted of or included elaborate sculpted memorials. These might be in the form of a rectangular urn shaped like a temple, or gessoed and painted aediculae surrounding the niches on which the memorial rested. In addition to these actual containers of the remains, portraits in marble or bronze were often placed on a separate shelf which would, like the niche with the urn itself, be identified by an inscription bearing the name of the deceased and the essential facts of his or her life, including a recitation of the number of years, months, and days lived, his profession, the high esteem in which he was held by his

survivors, and, as often as not, an affirmation of his piety.

Roman burials in the form of cippi or altars routinely include likenesses of the deceased, which may be carved of a single person, or more rarely, of a man and wife. These are often elaborate memorials in marble, and eventually the tradition of this category of portraiture is transmuted in the second century. Beginning under the emperor Hadrian, full-length sarcophagi begin to replace marble urns as cremation is superceded by inhumation.

Sarcophagi provided a remarkable field for portrait sculptors, both in the field of the sarcophagus front, and often on the lids as well. Earlier forms of funerary commemoration included the class of objects known as freedmen's reliefs, examples of which adorned the facades of ambitious monuments placed on roads leading out of the major cities of the Roman Empire. These often generalized likenesses presented the opportunity for freed slaves to aim at the preservation of their memory and that of their relatives through relatively lavish dedications.

As mentioned above, the funerary likenesses of Romans before the advent of sarcophagi as a major industry were often placed in niches inside columbaria, large chambers containing numerous niches. Among the most important found to date is represented in this exhibition; it remains one of the best preserved contexts for funerary portraiture in the Roman world. We will accordingly consider its features in some detail.

The three Vigna Codini columbaria, although filled with invaluable information about the burial practices of Rome at the beginning of the first century A.D., are complex subjects for our consideration, since they were opened as early as 1840, at a time when scientific excavation had yet to be developed. The structures surmounting the Vigna Codini Columbaria stand to this day, near the intersection of the Via Appia and the Via Latina.

The Columbaria of the Vigna Codini have a long history of publication and have been on occasion confused with one another or with neighboring tombs. Several columbaria were discovered in the vineyards of the Codini family from the mid fifteenth century onwards, and these included one drawn by Pirro Ligorio and published in his 1768 volume *Gli antichi sepolchri* (pls. 39-41). All but three, however, were destroyed through the misguided efforts of over-zealous amateur excavators and the flagging enthusiasm of papal administrators for these pagan monuments.

The first columbarium, according to the modern numbering system (I, II, III) was excavated in 1840 by G.P. Campana, and published that year in *Di due sepolchri romani del secolo di Augusto scoverti tra la via Latina e l'Appia presso la Tomba degli Scipioni* (Roma 1840). Columbarium I appears to be the latest of the three, although it resembles II in structure; the inscriptions are all from the reigns of Tiberius through Claudius.

Columbarium III was discovered in May of 1852 by Giovanni Bat-

tista Guidi. In shape, this columbarium is arranged as a corridor with three wings. The niches are square, rather than arched, and the walls are divided from each other by pilasters. Columbarium III was reopened after its initial dedication for freedmen of Augustus through Claudius and reused during the Trajanic and Hadrianic periods, shoehorning more niches in an already congested interior. The portion of the columbaria above ground are in large part reconstructed. The exterior consists of *opus latericium* (brickwork) with travertine details; there are immured inscriptions and sarcophagus fragments which were discovered during the first campaigns of excavation.

Of the three columbaria at the Vigna Codini, it is all but certain that the three portrait busts were found in the second. This columbarium was excavated in February of 1847, and was initially published by G. Henzen in the *Bulletino dell'Instituto di Corrispondenza Archeologica* in March of that year. From inscriptions in the tomb, we know that it was the earliest of the three Columbaria in the Vigna Codini, and was constructed in A.D. 10, during the consulship of Sergius Lentulus Maluginensis and Q. Junius Blaesus (*CIL* 6.2.4418). The columbarium was built by a corporation, and the deceased whose cremated remains were placed therein were the shareholders of the corporation. There were 295 niches altogether in the tomb, and well over 400 loculi, or funerary tablets. The floor was a donation of two shareholders, one a freedman of Sextus Pompeius, and the other of C. Memmius. The inscriptions from the tomb prove that the majority of the occupants were freed slaves and servants of Marcella the Elder, who was married to Julius Antonius after she had divorced M. Agrippa in 21 B.C., as well as of Marcella the Younger, who was first married to Paullus Aemilus Lepidus and subsequently to M. Valerius Messalla.

The exterior entrance of the tomb gives access to a stairway with twenty-one steps leading down to the floor of the tomb, which is approximately seven meters below the entrance. The interior of the columbarium is roughly rectangular, and measures 5.90 meters by 5.30. All four walls have nine rows of niches, separated from the next by about 67 cm. Each row of wall B has eight niches, whereas walls A and C have nine, and wall D has seven.

The pilaster which interrupts Wall A (west) has four rows of niches, included a marble olla, or cinerary urn, in the lowest of its niches, and the bust of the young woman, which was standing in the niche it occupied at the time of the photograph illustrated in Parker as early as 1877. Although the marble inscription plaque below the niche bears the name of Philia Julia, there is no guarantee that this is the original inscription. The niche in which the bust stood measured 57 cm. in height, 30 cm. in width, and 23 cm. in depth. Surrounding the loculus plaque identifying the sitter was a stucco frame painted in red and blue. Stucco survives in fair quantities in Columbarium II, in some cases with painted inscriptions as well as with marble plaques. Below the stairway leading up

from the tomb are traces of fresco painting, the remains of which include branches with small green leaves, fruit, and cult objects hanging from the branches. Such painted decoration would doubtless have been used on all walls of the tomb.

Like the remainder of the tomb, Wall B (south) underwent restoration at the time of the tomb's excavation in 1847, and during successive campaigns in 1888, 1906-7, 1942, and 1965. On Wall B there endures a fair amount of plaster work with traces of paintings of fruit and leaves, as well as the inscription of a collegium symphoniacorum, "qui sacris publicis praestu (sic) sunt," (CIL 6.2.4416) attesting to their certification to perform in public.

Wall C (east) has the best preserved plaster work, and in the tympana and other parts of the preserved loculi there are still visible a few painted figures modeled in white stucco on a blue background.

Wall D (north) is symmetrically bisected by a group of larger niches, four in all, which are 53 cm. high, 47 cm. wide, and about one foot deep. It appears that these niches were simply enlarged from existing niches at a date after the original construction and use of the columbarium. It further appears that the two marble busts of male sitters from the Vigna Codini were set in the enlarged niches of Wall D; the other two niches may have been enlarged to contain ollae with the cremated remains of yet another well-to-do interloper in the original arrangement of the tomb.

The enlargement of the niches, although dating after the tomb's A.D. 10 construction, need not have been significantly later, since the adjoining tombs I and III, of later date, would have been appropriate for burials under Tiberius or Claudius. The niches date after A.D. 10-14, while the three portraits of the Vigna Codini were inserted in Walls A and D of Columbarium II during the course of the first century A.D. Their interment in this tomb points to their service to the first imperial family, and their relative importance in the household, being among the very few to merit sculpted commemorations in marble.

As mentioned above, the loculus plaques below each of the enlarged niches are of no use in identifying the sitters, since many of the plaques were apparently recovered from the floor of the tomb and set back in the walls in an indiscriminate fashion. The situation may not be as bleak as modern scholars have suggested; in the initial excavation report of March, 1847, Henzen notes that a portion of the inscriptions were still affixed to the wall at the time of discovery. Careful examination on the site may reveal which were reattached and which remain in their proper place. The situation is, however, undeniably compromised by the commercial appetites of various members of the corporation associated with the columbarium. Some members sold their niches to others; one inscription from Columbarium I (CIL 6.2.4884) recounts that a niche was sold by Porcius Philargurus to Pinarius Rufus, who thereafter sold it to Sotericus Lucer. If the niches containing the busts

in Columbarium II were also enlarged as a consequence of their sale after the tomb's construction, which seems probable, the sitters commemorated by the portraits would have purchased the niches from one or more of the shareholders with the understanding that their busts could be accommodated therein. The fact that the portraits date from the Julio-Claudian and Flavian periods suggests that the enlargement of the three central niches in the third row from the bottom of wall D and the enlargement of the central niche in the fourth row from the bottom might have been undertaken early on, and that the male portraits were substituted for ollae or other portraits. Apart from the smaller family columbaria which continued to be built into the second century A.D., like those near the Basilica of S. Paolo (nos. 16 and 18), there seem to have been no columbaria of this size built after the reign of the emperor Claudius, and the reuse of existing underground tombs probably continued into the second century A.D.

Despite the uncertainties that surround an archaeological site uncovered without regard to maintaining it as intact as possible, and later subject to intrusion and theft, the second Columbarium of the Vigna Codini presents an unparalleled resource for understanding the use and placement of portraiture in a funerary context. The questions posed by this columbarium are fascinating, in that we may viscerally experience the objects in their original musty setting, seen in the company of less fortunate members of this funerary corporation whose descendants had to make do with simple plaques and terracotta containers rather than elaborate marble memorials. The pride and *dignitas* evident in the three likenesses from the Vigna Codini are especially poignant in light of their destination. No less than the ambitious above-ground monuments dedicated to members of the servant class in Roman society, these portraits are best appreciated in their context, as more than documents of taste and fashion, but as the sole surviving evidence of human lives.

The history of Roman portraiture looks very different when surveyed not by typological and chronological means, but through a consideration of function and context. The study of portraiture in Roman society grew out of a nineteenth-century interest in associating ancient images with known historical figures, and developed into a contemporary interest in more precisely determining the evolution of portrait types. At this stage in the continuing process of learning about ancient likenesses, our purpose has been to pause and reflect upon the settings of ancient art rather than to volunteer one more positivistic experiment in typology. We are not urging any suspension of judgment, but are encouraging the fullest possible use of evidence in future of the field, out of a sense that the discipline will flourish only if we able to make its value apparent to scholars and non-intiates alike.

Unless otherwise noted, the abbreviations are those used in The American Journal of Archaeology.

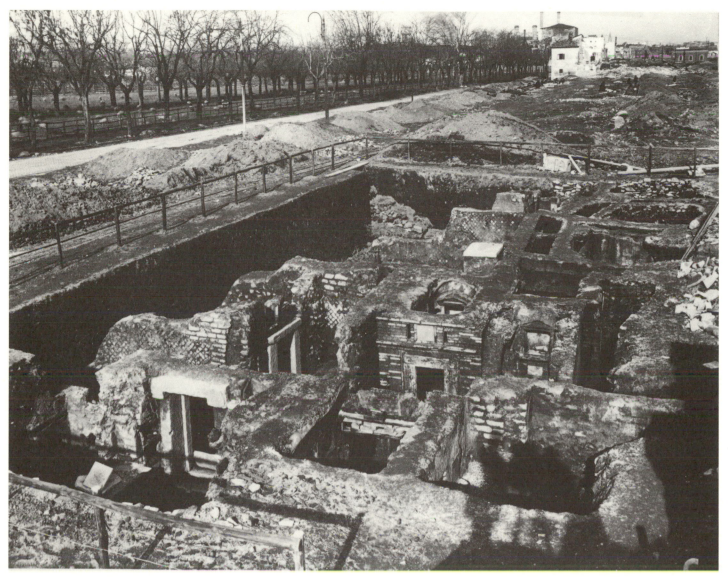

Rome, Sepulcretum of S. Paolo: general view taken during the excavation of 1919, F.U. 13532 F. Fototeca Unione, at the American Academy in Rome.

ca. 40-30 B.C.
Luna marble: h. 31 cm.
Provenance: Tivoli, Bath complex of the Acquae Albulae
Discovered in September 1953
Inv. n. 126391

This underlifesize bust is sharply cut on the top the head to receive a wig made separately. The nose is broken, and there are losses in the hair and left ear. The right earlobe was bored for an earring. The cutting at the base is evidently in preparation for insertion in a herm.

Although this small portrait suffers from its incomplete state, in missing the hairpiece which would have been added originally, it is intriguing because of its early date and findspot. In the late Republican period, Tivoli was peppered with well-to-do private residences, in much the same way as the region around Naples. The portrait was discovered in September of 1953 beneath a street which leads to the Acquae Albulae, under the property of Mr. Gaspare Prosperini in the area known as Pantani, approximately twenty kilometers towards Tivoli on the Via Tiburtina. Also found at the site was a trapezophoros with lion's heads and paws. The associated find of furniture suggests that the portrait was a commemorative one in a private context, perhaps in a villa in the area inhabited towards the end of the Republic.

The Acquae Albulae were to the Romans of antiquity as they are today the site of recuperative baths, originally restored and enlarged by Agrippa. A series of poligonal paving stones were recovered at the site as well, and it appears likely that the portrait was intended for display in a private home by the side of the road.

The sculptural technique of leaving the hairpiece as a separate adjunct is frequently employed in antiquity. [1] The Alexandrian method, in large measure invented, it seems, to compensate for the difficulty in acquiring large blocks of fine marble in North Africa, need not be seen to suggest the portrait's origins to be North African. Hiesinger feels certain that the portrait is a local Italian work in a pseudo-classical style. [2] The piecing argues against a funerary function for the work, since it would be less easily explicable to have such an elaborate depiction of a woman in a funerary setting at this early date than to have a commemoration of a private individual of some means. In the vicinity of the Acque Albulae were the largest quarries of travertine marble near Rome, measuring some 500,000 meters square, and the adoption of a Luna marble for this portrait was doubtless the consequence of choice, not necessity, given the ready availability of admittedly mediocre marble nearby.

[1] (J.R. Crawford, Capita desecta and marble coiffures, *MAAR* I (1917) 103 ff.; O. Vessberg, *Studien zur kunstgeschichte der römischen Republik* (Lund 1941) 221-22; *idem, Roman Portrait Art in Cyprus, Opuscula Romana* I (1954) 160 ff.; K. von Weinberg, *Mittelmeerische Kunst, Eine Darstellung ihrer Strukturen* Ausgewaehlte Schriften III, (Berlin 1965), chap. VI, Italien, pp. 333 ff.; and VII, Rom, pp. 401 ff.
[2] He compares it with a marble bust in the Museo Torlonia (Mittlemeerische pl. 130, 1, a bronze bust in Parma (pl. 130, 2; and with a male portrait from Canosa (G. Andreassi, Un ritratto romano repubblicano da Canosa, *Archeologia Classica* 23 [1971] 77-87).

Bibliography: For the Acquae Albulae, see: CIL 14.3908-12; T. Ashby, *Papers of the British School at Rome* 3 (1906) 117-120 ff.; *NSc* (1902) 111 ff.; *NSc* (1911) 287; *NSc* (1926) 413 ff.

For the portrait, see D. Facenna, Ritratto di Giovane donna da Bagni di Tivoli, *ArchCl* 7 (1955) 24-32, pls. 12-14 (dates ca. 30 B.C.); idem, in *NSc* (1957) p. 153; FA 8, 1953 (1956), p. 2345, n. 3147, 235, f. 71; U.W. Hiesinger, *ANRW* I, 4 (1973) p. 813, pl. 169; W. Trillmich, Das Torlonia Mädchen (Goettingen 1976) p. 2955, pl. 6, 1-4; Fittschen-Zanker III, p. 38.

<div align="right">M.L.A.</div>

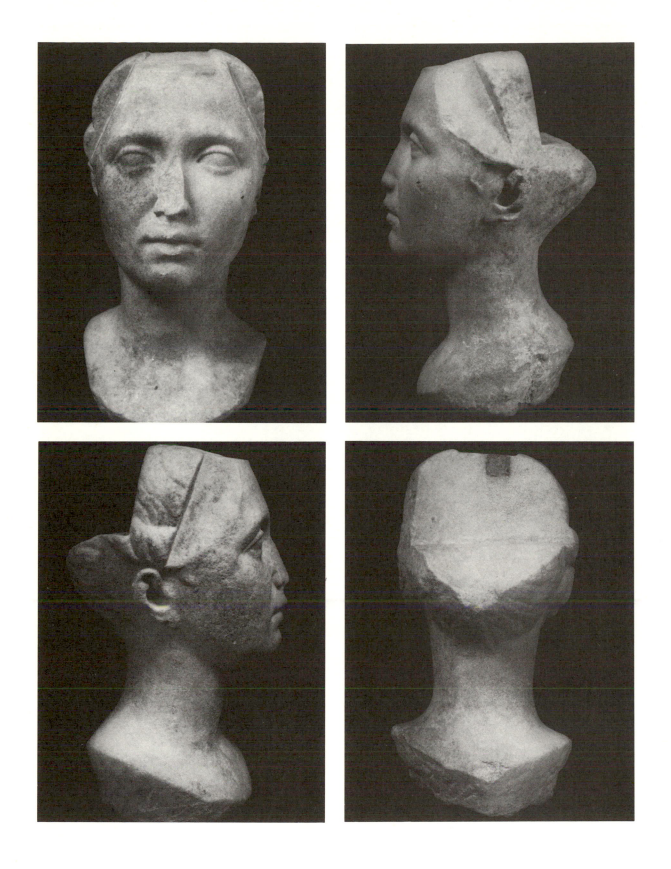

ca. 25-20 B.C.
Luna marble: h. 36.5 cm.
Provenance: Rome, via Latina, Columbarium beneath a garden in the Casa Generalizia dei Padri Marianisti
Discovered in 1948; acquired on June 5, 1949
Inv. n. 125591

This expressive portrait of a young woman is well preserved, except for some chips in the right eye and the right side of the bust. The earlobes are drilled for the insertion of earrings, and the hair is brushed up into a loose topknot, braided behind the ears, and gathered into freely arranged shoulder locks.

The Via Latina is a road which in antiquity branched off to the left from the Via Appia about 830 meters from the Porta Capena, and after another 500 meters passed through the Porta Latina of the Aurelian wall of the city. Eleven miles of tombs constitute the primary feature of this important artery in and out of the capital, which began its life as a military supply road. According to Livy (10.36), it ran as far as Cales by 334 B.C.
This portrait was discovered in 1948 in a columbarium on the Via Latina, together with epigraphical material published in 1975. The material came from the garden of the Casa Generalizia dei Padri Marianisti (Via Latina, 22).
The epigraphical evidence assembled from the columbarium has a wide chronological range. The inscriptions considered by Solin date from the early first century B.C. (nos. 52 and 53) to the early fourth century A.D. (n. 63). The long life of the columbarium suggests that it may, like the Vigna Codini columbaria, have been taken over by later burials of second-century date, which makes the presence of a portrait of such relative antiquity all the more extraordinary.
The other deceased commemorated in the tomb include free – born citizens of Rome, and it is not to be assumed that this young woman was a freedwoman. It was probably placed in a niche along with other members of the family. The cutting of the base of the portrait makes it probable that the bust was inserted in a small herm.
The presence of such a fine portrait of a woman at this early date in a columbarium requires some explanation. If some so-called funerary portraits executed in marble are commemorations from the lifetime of the sitter that are simply transferred to the tomb following their death, rather than portraits executed with the tomb as a specific destination, this image would most likely be of a well-to-do citizen. If, on the other hand, the portrait was made with a funerary purpose in mind, it could have been the extravagant investment of a bereaved family of liberti. The relatively cheerful expression of the sitter and the rather unsober hairstyle leads one to see this as a portrait made in the sitter's lifetime. The full treatment of the back of the head also suggests that the portrait was not originally funerary in purpose, but that it was eventually transferred to the tomb.

Bibliography: FM 83; L. SENSI, in *Ann.Lett.Filos.Perugia* 18 (1980-81) p. 83; H. SOLIN, *Epigraphische Untersuchungen in Rom,* Helsinki (1975) 27-35; *Mus.Naz.Rom.,* I, 9, 1, 121-123; M.R. DI MINO. Mus. Naz. Rom. I, 9, 1, 121-23. For the Via Latina, see S.B. PLATNER, A Topographical Dictionary of Ancient Rome (London 1929) 564-65.

Neg. no.: 215213L

M.L.A.

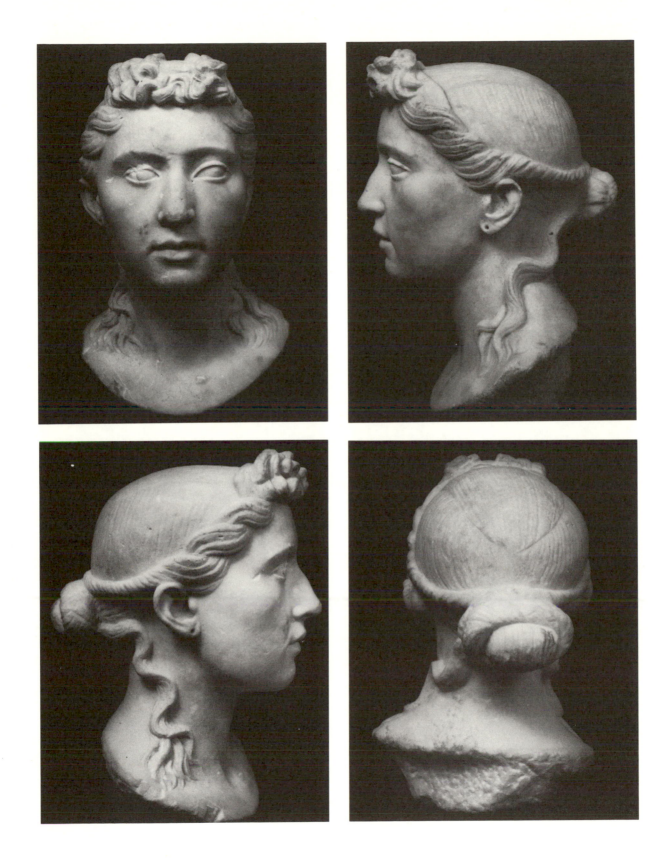

Mid first century A.D., perhaps Neronian (A.D. 41-54)
Luna marble: h. 30 cm.
Provenance: Roma, Off the via Varese
Discovered in April, 1940
Inv. n. 121316

Overlifesize portrait head of a woman wearing a high diadem. The hair is parted in the center, and arranged in three rows of curls. The ears are bored for the insertion of earrings. The top and rear of the head are summarily worked. Damages to the nose, mouth, chin, forehead, left ear, top of the diadem.

The erection of the Banca d'Italia along the Via Varese in April of 1940 occasioned the discovery of a variety of objects in the center of the block now defined by the Via Milazzo, via Marghera, via dei Mille, and via Varese. In addition to this portrait were recovered the marble head of a satyr (M.N.R. inv. 121315), [1] a head of a maenad (121319), the fragment of a sculpted tree trunk with a ramskin (121318), the head of a statuette of a maenad (121317), a fragment of a leg from a male statue (121320), and fragments of a cornice and capital.

This northeastern section of the city (Region V), bordering on the Castra Praetoria, was apparently dedicated to private residences. The decorative Bacchic statuary recovered with this portrait points to a private home, and this large posthumous image of a female member of the imperial family would have been an honorary portrait, perhaps Neronian or early Flavian in date. It was once presumed to depict Agrippina, and be of the third portrait type, like a portrait of Agrippina in the Museo Nazionale (inv. 56964). R. Bol recently made a convincing case that the portrait depicts not Agrippina, as was long assumed, but Claudia Octavia, the daughter of Claudius and Valeria Messalina.

The decorative sculpture recovered along with the head dates in part from the second century A.D., suggesting that the private residence would have been occupied for at least a century after the manufacture of the portrait.

The active construction program during the war years revealed a considerable amount of archaeological material in the heart of the modern city, which was often accompanied with responsible recording of the finds; careful excavation in this instance might have yielded yet more valuable information about the setting. Even if the commemoration of members of the imperial family was common in private households, overlifesize portraits were perhaps less so, and the site may hold interest as the residence of a citizen of high standing.

[1] H. 33 cm. Neg 147672, perhaps Hadrianic in date from restrained use of the drill.

Bibliography: K.C., *Bollettino della Commissione Archeologica Comunale di Roma,* 72 (1946-48) 188; FELLETTI-MAJ 111; K. FITTSCHEN, *Pompeji, Leben und Kunst in den Vesuvstaedten* (Essen 1973) p. 38, n. 16; W. TRILLMICH, in *Madrider Mitt..* 15 (1974) 195, n. 56; *Carta Archeologica di Roma* III (Florence 1977) III-G, p. 232, n. 127; K. FITTSCHEN, P. ZANKER, *Katalog der römischen Porträts in den Capitolinischen Museen und den anderen kommunalen Sammlungen der Stadts Rom, vol. III* (Beiträge zur Erschliessung hellenistischer und Kaiserzeitlicher Skulptur und Architektur, vol. 5) (Mainz 1985) 6-7, no. 5, n. 4 (Type III, Ancona), replica o (of Agrippina Minor). R. BOL, Claudia Octavia aus dem Olympischen Metroon, *JdI* 101 (1986) 289-307, fig. 9; B. DI LEO, in *Museo Nazionale Romano, Le Sculpture,* I, 9, part I (Rome 1987) 155-57;

Neg. no. 215451L; GFN. F 24363; AFS 215452

M.L.A.

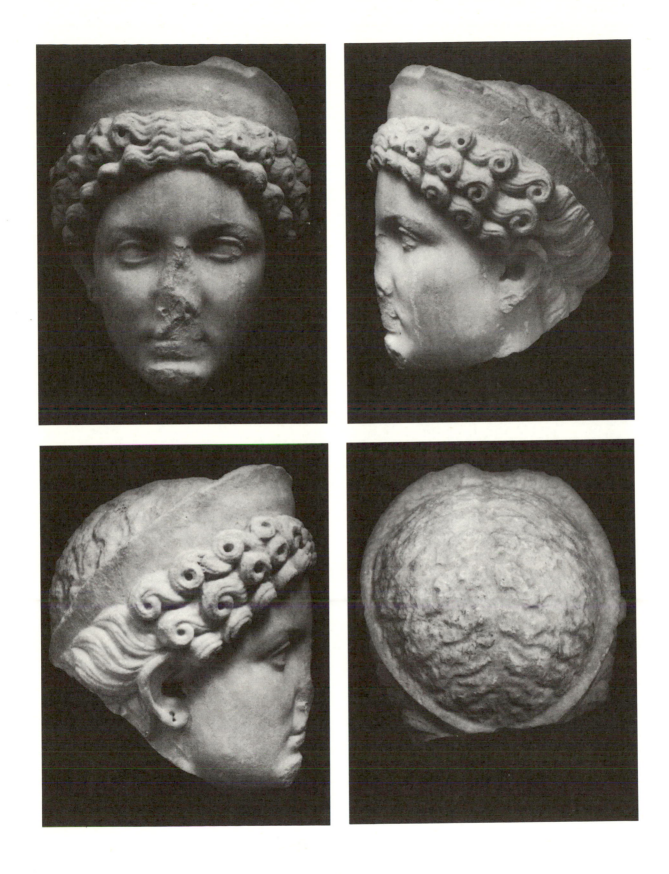

15. PORTRAIT BUST OF A MAN

Perhaps Claudian-Neronian, ca. A.D. 40-60
Luna marble, h. 42.3 cm.
Provenance: Vigna Codini Columbarium II, via Latina, Rome
Museo Nazionale Romano, inv. n. 370932

This portrait bust of a man has had the left shoulder reattached. There is a plaster fill in the front of the bust. The head is turned towards the right, and the sitter wears a full cap of hair which tends from the lower left of the forehead to the upper right. The eyebrows jut out slightly, and the nose and ears have broken off.

Like the portrait bust of a young woman described below, this image was discovered in Columbarium II of the Vigna Codini during the 1847 excavations, but was spared destruction or theft by a happy combination of circumstances.
The portrait was photographed in the tomb, in a view that was published by J.H. Parker in *The Archaeology of Rome* (vols. IX-X, *Tombs in and Near Rome* [Oxford and London 1877] pls. II and III). It appears, along with the portrait described below, in a central niche on the north wall of the tomb.
The portrait remains firmly anchored in the tradition of Julio-Claudian potraiture, including faint worry lines, a concerned expression, and delicately modeled hair, which is not totally symmetrical.

M.L.A.

16. PORTRAIT BUST OF A WOMAN

Perhaps Neronian, A.D. 54-68
Luna marble, h. 39.5 cm.
Provenance: Vigna Codini Columbarium II, Via Latina
Inv. n. 370931

This portrait of a young woman is in extremely good condition, except for the loss of several curls of hair on the top of the head. The hair is parted in the center, braided in back, descending to a plait, and has five rows of curls with twelve curls in each row.

The astonishingly fine condition of this sculpture is evidently owed to its long interment in Columbarium II of the Vigna Codini in Rome. Its distinctive hairstyle relates the portrait to a series of likenesses from the mid first century A.D. Elaborate curls of the kind that adorn the portrait in five rows are paralleled in sculptures dating from the Julio-Claudian period through the Flavian period, but there are enough similarities with securely dated portraits to place this work in the middle of the first century A.D.
The sophistication of the workmanship argues for metropolitan Rome as the place of manufacture. In particular, we many compare the Licinius tomb portraits. [1]
The portrait was photographed, like the other two portraits from the tomb, in an Anderson print published in 1877. It appears in a niche on the west wall of the tomb, with what is very likely an alien inscription below to "Philia Julia", set in the wall after the 1847 excavation with the misguided intention of giving the interior a more finished appearance, rather than recording the original location of the presumably fallen loculus plaques.
The niche was enlarged, like those in which the two male busts and marble ollae were

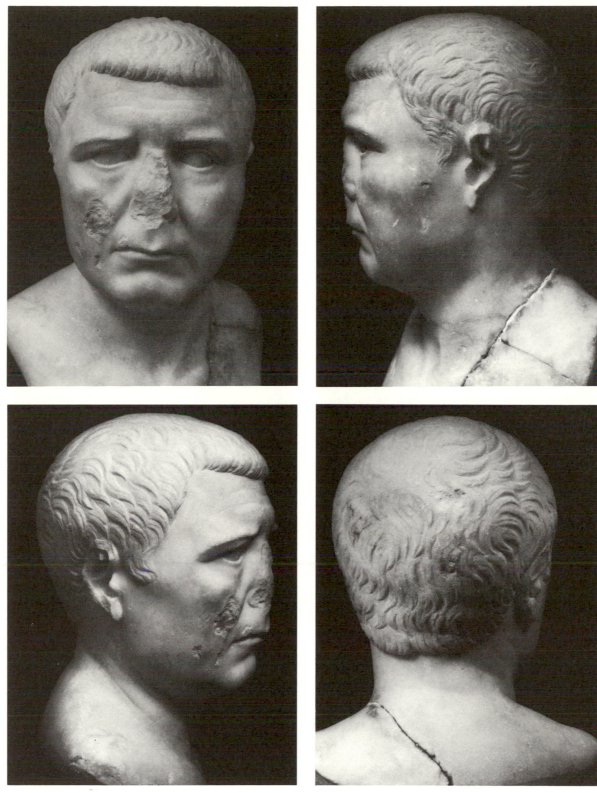

no. 15

placed on the north wall. The enlargement of the niche may date to the time of the portrait's manufacture, which would perhaps only suggest a later reuse of the Columbarium than has previously been entertained.

[1] D. Boschung, Überlegungen zum Liciniergrab, *JdI* 101 [1986] 257-287; V. Poulsen, *Les portraits romains I* (Copenhagen 1973) pp. 111-12, n. 75, inv. 742.

M.L.A.

17. PORTRAIT BUST OF A MAN

Perhaps Flavian, ca. A.D. 69-80
Luna marble, h. 41 cm.
Provenance: Vigna Codini Columbarium II, Via Latina, Rome
Museo Nazionale Romano, inv. n. 370933

The head is intact except for the top of the left ear, and a loss in the lower right portion of the bust. The shoulders of the bust are rounded, unlike those of the other male bust from the tomb, which are more square.

The portrait of an older man from the Vigna Codini second Columbarium seems to be the latest of the three images, based upon the rounded shoulders of the bust, the close-cropped hair, smooth features, and elements of a revival of late Republican style. It seems to confirm that while the niches in which these portraits stood were made at one time, the sculpted commemorations were probably placed in the tomb at different times, as a result of the sale of niches by one or more members of the corporation of shareholders.
Although he at first sight appears to be bald, the Flavian sitter actually has a fairly full head of hair which is very close-cropped. The rounded shoulders of the bust, crewcut, and smooth features point to a date near the reign of Vespasian (A.D. 69-79).
The damage to the bust and faint traces of incrustation on the surface point to the portrait's having had a life before its arrival in the tomb, but this need not indicate anything more than that the bust was exposed to deteriorating conditions prior to its placement in the tomb.

Bibliography: Cf. P. Pensabene, Un colombario a Capranica, *Archeologia Classica* 35 (1983) 58-73; G. Grana-G. Matthiae, Colombario, in EAA II (1959) 746 ff.

M.L.A.

All three portraits from the Vigna Codini columbaria were recovered from Columbarium II, which is a rectangular enclosure with nine rows of nine niches in each wall. The majority of those buried in the tomb, it is clear from the inscriptions immured beneath each semicircular niche, were slaves or freedmen of Livia, the Elder Drusus, Marcella the Elder, and Marcella the Younger. The mosaic floor of the tomb was set, according to another inscription in the tomb, in A.D. 10.
There are, among the deceased commemorated in the tomb, a variety of servants for the imperial family. The question raises itself as to why portraits from a generation or more after the construction of the tomb should be placed among commemorations of

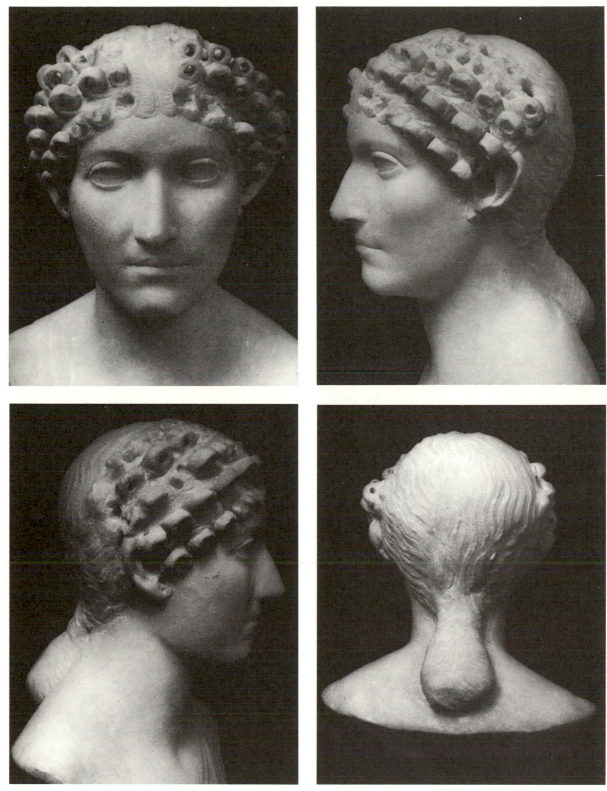

no. 16

the Augustan period, when there were adjoining columbaria created during the Julio-Claudian dynasty. It cannot be ruled out that the portraits, although executed from the Claudian to the Flavian periods, are fashionable and lavish replacements of lesser works that were original to the Columbarium. But this explanation is not especially reasonable; it is far more likely that the portraits were placed in their respective niches at various times, replacing the original commemorations of each niche. The enlargement of the niches would then date just before the insertion of the earliest of the three portraits, that of an older man, which may date from the 40s A.D. The other enlarged niches probably contained secondary commemorations prior to being displaced by the female and male portraits recovered from the tomb, nos. 16 and 17. According to this explanation, the Flavian portrait, no. 17, would have been among the last additions to the tomb prior to its reopening at various points in the postclassical period for looting, and eventually for the 1847 excavation.

For Vigna Codini Columbarium II, see: G. Henzen, in *Bullettino dell'Instituto di Corrispondenza Archeologica* (1847) n. 3, 49-51; E. Braun, *Bullettino dell'Instituto di Corrispondenza Archeologica* (1852) 82; W. Henzen, *Annali dell'Instituto di Corrispondenza Archeologica* (1856) 18; CIL vol. 6.2.4418-4880; J.H. Parker, *The Archaeology of Rome IX: Tombs in and Near Rome* (Oxford and London 1877) 15-17, pl. II (west and north walls, with portraits), pl. III (detail of north wall, with male portraits) R. Lanciani, *The Ruins and Excavations of Ancient Rome, A Companion Book for Students and Travelers* (Boston and New York 1897) 330-331; H. Jordan, C. Huelsen, Topographie der Stadt Rom in Alterthum I (Berlin 1907) 211-12; G. Lugli, *I monumenti antichi di Roma e Suburbio I:* La Zona archeologica (Rome 1930) 450-452, fig. 102: north wall of II cubiculum, with two male portraits) 450-52; M.E. Blake, *Ancient Roman Construction in Italy from the Prehistoric Period to Augustus* (Washington, D.C. 1947) 272-73; EAA II (1957), "Columbario", 746-48; E. Nash, *Bildlexicon zur Topographie des antiken Rom* (vol. II) (Tübingen 1962) 333-339, figs. 1106-1110: listed under Sepulcra Familiae Marcellae et aliorum. For Columbarium II, see 1106 (Arch Vat XVIII-8-2), East and south sides; and especially 1107 (Anderson 264), West and north side (with busts); G. Lugli, *Itinerario di Roma Antica* (Milan 1970) 550; J.M.C. Toynbee, *Death and Burial in the Ancient World* (Ithaca 1971) 114; F. Coarelli, *Guida Archeologica di Roma* (Rome 1974) 336-37; R. Lanciani, *Rovine e Scavi di Roma Antica* (Rome 1985) reissue of The Ruins and Excavations of Ancient Rome, (London 1897) 291-95, fig. 128; R.A. Staccioli, *Guida di Roma Antica* (Milan 1986) 56-58.

no. 17

ca. A.D. 130-135
Greek marble; h. 27 cm.
Provenance: Ostia, Sanctuary of the Magna Mater
Date of discovery: Spring of 1869
Inv. n. 341

There are traces of red on the diadem and in the hair on the left side of the head, newly revealed through cleaning. The portrait is broken at the neck, and the nose is lost. The irises are incised and the pupil is rendered with a single faintly drilled hole. The busts on the diadem are extremely weathered; that on the proper left appears nude save some drapery on the left shoulder, and that on the right wears a himation with drapery on the left shoulder as well. The head is worked in back, but not quite as thoroughly.

As the port city that furnished Rome with its imported goods and sevices, Ostia kept some imported traditions to itself. Cybele was the first eastern god to arrive there, and perhaps the last to cede to Christianity. The sanctuary to the Magna Mater at Ostia is a roughly triangular enclosure some 4500 meters square, located adjacent to the Laurentian Gate, with access from the cardo maximus.
Unlike the older cult of Cybele, the cult of Antinous at Ostia follows directly from Hadrian's role as benefactor of this important colony. The spread of Antinous's cult after his death in A.D. 130 (Dio 69.11.4) was swift, and Ostia has furnished other statues of Antinous. [1] This portrait of Antinous from the Campus Magnae Matris is especially informative, since the findspot has proven essential to its proper interpretation. Following its discovery in the spring of 1869 in the field of the Magna Mater, the portrait excited much comment and speculation. Yet it was not until Calza's 1965 catalogue of the Ostia portraits that the findspot of the portrait was taken into consideration in interpreting the object's significance. The two busts on the diadem had been earlier presumed (Paribeni 1934) to represent Nerva and Trajan. It was the singularity of the feature of the diadem that led Calza to assert the pertinence of the portrait's provenance in identifying the busts as divinities in the cult of Cybele. The image of Antinous has thus been established to depict the young lover of Hadrian in the guise of a priest of Attis, the young lover of Cybele.
The portrait of Antinous can be assumed to have surmounted a statue which stood outdoors or a bust which was displayed indoors. As a priest of Attis, the statue would have decorated the sanctuary of the god, together with other figures. It remains a document of the use of official state portraiture in the service of religion – in this case, of a cult imported from distant Phrygia.
The posthumous statue of Vespasian, part of which was recovered along with this portrait, is less easily explained in this context, and its arrival on the site almost certainly predates the dedication of the sanctuary to Cybele. [2]

[1] P. MARCONI, *MonAntLinc* 29 (1923) 194, n. 86, from the Baths of the Porta Marina; and one from the Tor Boacciana PASCHETTO, *Ostia colonia romana, storia e monumenti* (Rome 1912) 490-93; MARCONI p. 170, n. 16; A. GIULIANO, *Catalogo dei ritratti Romani del museo profano Lateranense* (Vatican City 1957) p. 50, n. 55.
[2] For the portrait statue of Vespasian (M.N.R. inv. no. 330), see R. CALZA, I Ritratti (Roma 1965) no. 62, p. 45, pl. 36; FELLETTI-MAJ no. 141; HELBIG 4 no. 2310, p. 227; S. AURIGEMMA, *Le Terme di Diocleziano e il Museo Nazionale Romano* (Rome 1946) no. 319, p. 117; M.N.R., *Le Sculture*, I, 4 (Rome 1979) no. 173. Negatives: AFS 147567; Anderson 2065; Alinari 17378. H. 39 cm. The overlifesize head was by Calza associated with a colossal arm and leg found together with the statue (op. cit. p. 45). The rear of the head is summarily worked, and the statue may therefore be assumed to have stood in a niche.

Bibliography: For discussion of the site in 1868, during the course of excavations, see: C.L. VISCONTI, in *Annali dell'Instituto di Corrispondenza Archeologica* 41 (1869) 208-245; MONUMENTI IN-

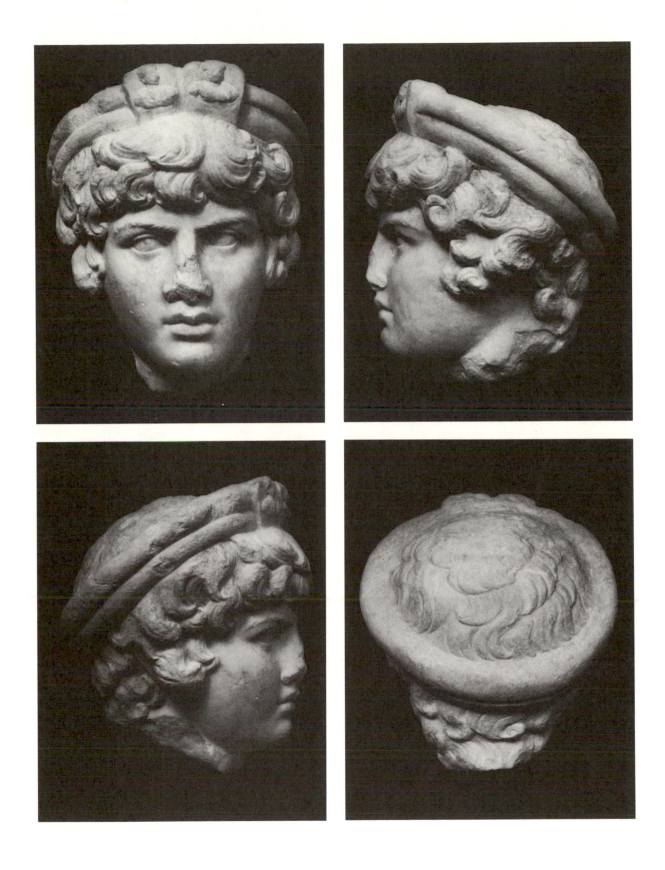

EDITI 9 (1869-73) pl. VIII, 2; pl. VIII, la-b.; more recently, see: R. CHEVALLIER, *Ostie Antique: Ville et Port* (Paris 1986) 232-39.

For the portrait, see – MARIANI, *Guida del Museo delle Terme* (Rome 1900) p. 16, n. 7; G. BLUM, in *Melanges d'Archeologie et d'Histoire, Ecole francaise de Rome* 33 (1913) 6580; P. MARCONI in *MonAntLinc* 29 (1923) cols. 171 ff., n. 19; G.A.S. SNIJDER, *Ein Priester de Magna Mater aus Smyrna,* in *Oudheidkundige Mededeelingen* 13 (1932) 113; A. HEKLER, *La Critica d'Arte* 15 (1938) 92 ff.; R. CALZA, *MemPontAccadArch*, III series, vol. 6 (1946) 216 ff.; n. 89; C. PIETRANGELI, *I monumenti dei culti orientali nei musei Capitolini* (Rome 1961) 1420, ns. 16, 28, 29; R. PARIBENI, *Il ritratto nell'arte antica* (Milan 1934) p. 35, pl. CCXXXIX; FELLETTI MAJ 191, p. 100: R. WEST, *Römische Porträtplastik* (Munich 1933-41) II, p. 138 ff.; PARIBENI, n. 770; PARIBENI, il ritratto, pl. CCXXIX; R. CALZA, *Scavi di Ostia, I Ritratti,* I (Rome 1965) n. 129, pp. 80-81, pl. LXXVII; C. CLAIRMONT, *Die Bildnisse des Antinous, Ein Beitrag zur Porträtplastik unter kaiser Hadrian* (Schweizerisches Institut in Rom. Bibliotheca Helvetica Romana VI (1966) p. 53, no 45; R. MEIGGS, *Roman Ostia* (Oxford 1973) 379.

Neg. nos. FN F 9448, 9528, 201363L

Cf. especially Vienna, DAI Inst. Neg. 62.1023, and London DAI Inst. Neg. 52.69

M.L.A

ca. A.D. 162-170
Greek marble; h. 25.5 cm.
Provenance: Roman Forum, House of the Vestal Virgins
Discovered between 1883 and 1900
Inv. n. 642

The face is highly polished. The nose is broken on the left side. The irises are incised and the pupils are indicated by heart-shaped drill holes. There are faint scratches on the surface of the face.

Numerous portraits of Faustina Minor survive, but few claim a provenance as suggestive as this example. Faustina's pertinence to the House of the Vestal Virgins, as a mother of thirteen children with Marcus Aurelius, requires some explanation.
The cult of the Vestals was among the oldest cults in imperial Rome, having its origins, according to Livy, in Alba (1.20; cf. Ovid, Fasti 3.46), and was said to have been imported either under Romulus or Numa. Although an earlier Republican period structure stood in the Roman Forum on the site of the Atrium Vestae, the residence as it remains today was apparently built after the fire during Nero's reign, in A.D. 64, and underwent restoration and enlargement during the reigns of Domitan, Trajan, and Septimius Severus.
The House of the Vestal Virgins, or Atrium Vestae, was discovered in 1883-84 during excavations conducted by Lanciani. The statues of the Vestals are the most notable remains of the site today; it included in antiquity halls and bedrooms, and it is likely that the portrait of Faustina Minor was part of a statuary dedication which commemorated the invervention and restoration of the Atrium Vestae during the reign of her husband Marcus Aurelius. Although none of the inscriptions surviving from the site testify to the active support of Marcus Aurelius, there is evidence of Antonine largesse shown toward the Vestals in the abundant finds of coins from the period, and especially abundant are coins of Faustina the Elder and Faustina Minor. The completion of the eastern half of the Atrium is in all likelihood Antonine, and very possibly was accomplished with the help of Lucilla. Faustina's help to the Atrium may have been acknowledged through the erection of a portrait statue with an inscribed base, but all evidence of such a dedication save the portrait head has vanished. A later inscription is dedicated to Julia Domna, the wife of Septimius Severus, as the restorer of the temple and the House of the Vestals (CIL 6.78), although no image of Julia Domna has been recovered from the site. Other portraits of imperial subjects have been recovered from the Atrium Vestae, including images of Lucius Verus, Geta, Caracalla, and Gallienus, and it may be that these dedications alla commemorate a campaign of restoration on the part of the persons depicted.

Portrait: FELLETTI MAJ no. 235; BERNOUILLI II, 2, p. 194, n. 6; FURTWÄNGLER - WOLTERS, n. 1694; *ArndtBr*, 75675-7; Helbig 3, n. 1416; HEKLER, pl. 284b; DELBRUECK, p. 53, pl. 47; Strong, p. 392, pl. 74; R. PARIBENI, *Le Terme di Diocleziano e il Museo Nazionale Romano* (Rome 1928) 244, no. 703 (ill. p. 245); BECATTI, p. 345, pl. CXLII 7; DUCATI, pl. CLV; POULSEN, JdI 47 (1932) 85, fig. 13; PARIBENI, n. 128; idem, il ritratto, pl. CCLXVI; WEGNER, pp. 53, 222, 281, pl. 35; K. FITTSCHEN, *Die Bildnistypen der Faustina Minor und die Fecunditas Augustae* (Göttingen, 1982) 60, no. 3, pl. 36, 1-4 (8th portrait type, from A.D. 162, the year of Annius Verus' birth).

For the *Atrium Vestae,* see R. LANCIANI, *NSc* (1883) 434-487; *id., The Ruins and Excavations of Ancient Rome* (Boston and New York 1897), pp. 226-232; id., *Storia degli Scavi di Roma* (Rome 1902-12) II, p. 203; H. JORDAN, *Der Tempel der Vesta und das Haus der Vestalinnen* (1886) pp. 5, 25-40; H. AUER, *Der Tempel der Vesta und das Haus der Vestalinnen* (1883) 3-10; J.H. MIDDLETON, *The Remains of Ancient Rome,* I, pp. 307-329; G. BONI, NSc (1899) 325-333; C. HUELSEN, *Das Forum Romanum* [2] (Rome 1905) pp. 182-194; E.B. VAN DEMAN, *The Atrium Vestae* (1909); idem, JRS 12 (1922) 29; W. HELBIG, *Führer durch die öffentlichen Sammlungen klassischer Altertümer in Rom,* 3rd ed. II, pp. 152 ff., nos. 1243, 1357-1361; CIL 6.32409-32428; H. *Thédenat,*

Le Forum Romanum et les Forums Impériaux (Paris 1923) 316-333; E. DE RUGGIERO, *Il Foro Romano* (Rome and Arpino, 1913) 275-293; S.B. PLATNER and T. ASHBY, *A Topographical Dictionary of Ancient Rome* (London 1929) 58-60; M.E. BLAKE, *Memoirs of the American Academy in Rome* 8 (1930) pp. 53 ff., p. 89; G. LUGLI, *Roma Antica, Il Centro Monumentale* (Rome 1946) 208-212; H. BLOCH, *I bolli laterizi e la storia edilizia romana* (Rome 1947) 67-85; M.E. BLAKE, *Ancient Roman Construction in Italy from the Prehistoric Period to Augustus* (Washington, D.C. 1947) p. 120; M.E. BLAKE, *Roman Construction in Italy from Tiberius through the Flavians* (Washington, D.C. 1959) pp. 45 ff.; F. COARELLI, Il Foro Romano vol. 2: Periodo repubblicano e augusteo (Rome 1985) 171, 173, 188.

For the portraits found in the *Atrium Vestae,* see R. PARIBENI (1928) as follows: LUCIUS VERUS, p. 241, no. 695, inv. 631; Geta, p. 244, no. 706, inv. 641; Caracalla, p. 245, no. 708, inv. 648; Gallienus, p. 246, no. 711, inv. 644.

Neg. no.: Anderson 2156; DAI Inst. Negs 426667; 1938.739,740; A.F.S. 423814 M2; 4239642401 M2; 42385-42388 M2; 44403-44410 L; 43606 M; 43611 M

Cf.: Capitoline, Salone 46, inv. 666, Fittschen-Zanker III p. 22, n. 21, pl. 30; type 8; A.D. 162-170.

M.L.A.

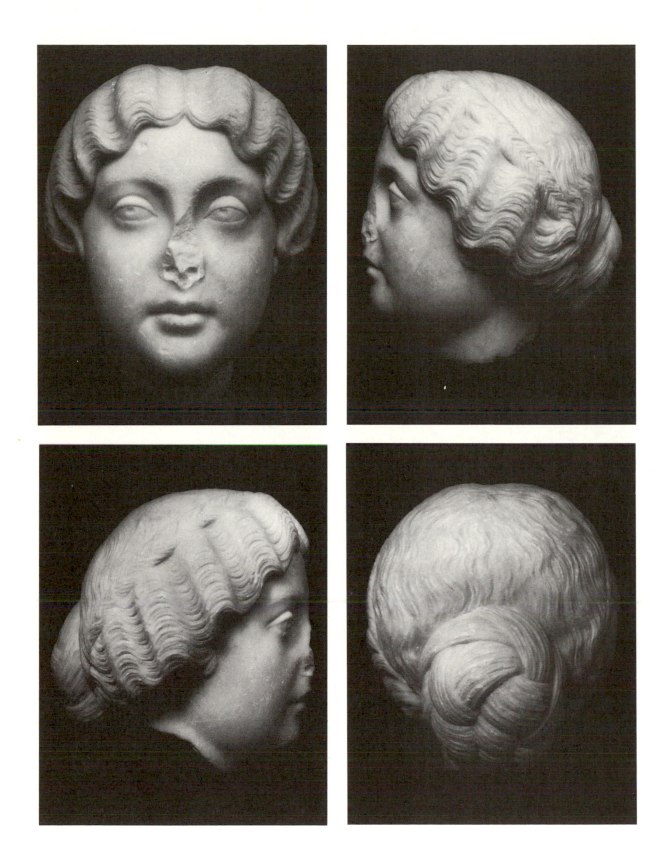

ca. A.D. 138-145
Luna marble: h. 24 cm.
Provenance: Roma, via Ostiense, from the foundations of the Quadriporticus of San Paola fuori le Mura
Discovered between 1897 and 1910
Inv. n. 52628

The nose is missing (a plaster restoration was removed in preparation for the exhibition) but the head is otherwise in fine condition.

This portrait was discovered in the foundations of the modern quadriporticus of S. Paolo on the via Ostiense. The Quadriporticus was added to the church between 1890 and 1928 above the remains of the first, Constantinian, basilica which was dedicated to Saint Paul. The site, approximately two kilometers south of the Aurelian walls of the city and the Porta Ostiensis, very likely contained the remains of a necropolis, which was covered over in preparation for the Constantinian monument. We have less information about the foundations of the Quadriporticus than we do about the neighboring necropolis to the eastern edge of the Roman road leading out of the city (see no. 21). It is nonetheless possible to observe that although the location of the shrine dedicated to St. Paul might have been known to the Antonine inhabitants of the region, the preponderantly funerary character of this area markes it all but certain that this portrait of a private person was part of an underground burial. It is not improbable that St. Paul, following his execution on June 29, A.D. 67 or 68, was buried below the present location of the Basilica of Saint Paul as well, and that the burial took place in a longstanding columbarium of at least first – century origins. The excavation of this site was occasioned by a fire that took place in the Basilica on July 15, 1823. There were further explorations in September of 1850, which revealed more precisely the existence of a "square sepulchral chamber with pigeonholes for cinerary urns. This tomb was found almost intact, but it seems that no attention was paid to it, no drawings taken, and no copies made of the inscriptions which probably accompanied each pigeonhole." (R. Lanciani, New Tales of Old Rome [London 1901] 166). More tantalizing evidence exists, such as the recognition by Lanciani of brick stamps dating from the time of Faustina Minor – from a few years after this portrait was made – but it is of limited help in placing the portrait more precisely. A plaster restoration of the nose (recently removed) was already in place when the bust was acquired by the National Museum in 1910, and it may therefore have been unearthed during an earlier phase of the explorations in the vicinity of the Quadriporticus and retrieved from private hands by the Museo Nazionale Romano.

Bibliography: FELLETTI-MAJ 212; PARIBENI, *B. Arte* IV (1910) p. 310 ff., fig. 7; PARIBENI (1932) no. 900. For the Quadriporticus, see J.-CH. PICARD, Le quadroportique de Saint Paul-Hors-les-Murs à Rome, *Melanges de l'Ecole Francaise de Rome* Antiquité 87 (1975) 1, pp. 377-395; R. KRAUTHEIMER et al., *Corpus Basilicarum Christianarum Romae,* The Early Christian Basilicas of Rome, vol. V (Vatican City, 1977); D. HOTH, *Die Basilika "San Paolo fuori le Mura" von Rom* (Diss. Hamburg 1981) 148 ff. For the tomb of St. Peter, see especially: R. LANCIANI, *New Tales of Old Rome* (London 1901) 163-67; E. STEVENSON, Osservazioni sulla Topografia della Via Ostinse e sul Cimitero ove fu sepolto l'Apostolo S. Paolo, in *Nuovo Bulletino di Archeologia Cristiana* 3 (1897) 283-321. For the via Ostiense, see PLATNER, *Topographical Dictionary,* pp. 565-66; Pliny, Ep. 2.17.2.

Cf.: Rome, Museo Nuovo IN 1936.1227; Zeri, Mentana IN 77.43, 77.40; Venice, Mus. Arch. Sala IX, n. 15, inv. 37, DAI Inst. Neg. 82.703; Venice, Sala X, n. 5, inv. 207; DAI Inst. Neg. 82.730, 82.731

M.L.A.

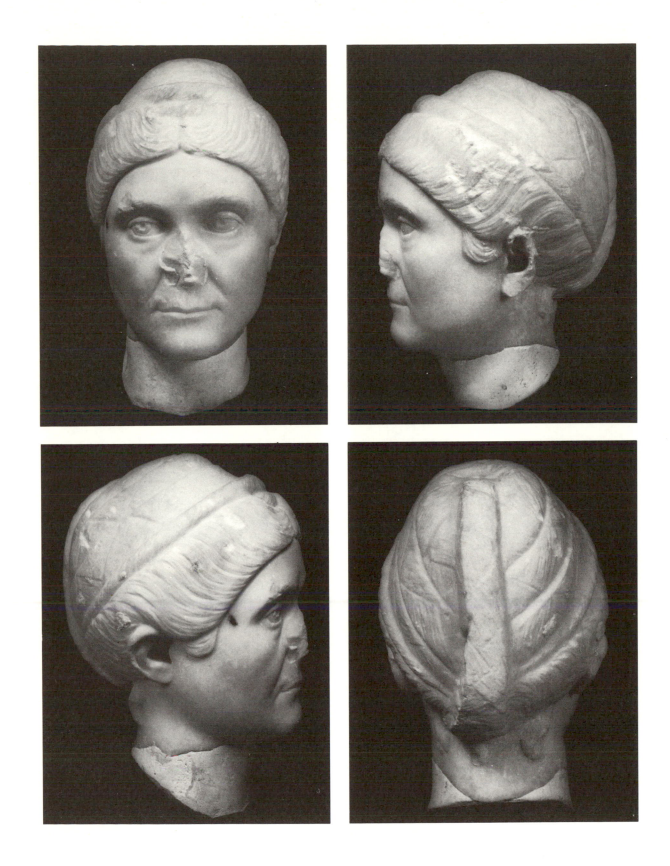

ca. A.D. 180
Luna marble: h. 32 cm,
Provenance: Via Ostiense, necropolis east of the Basilica of S. Paolo
Discovered between 1897 and 1910
Inv. n. 124494

The thick mass of curly hair is drilled with lozenge-shaped holes. The eyes seems to be squinting slightly. The nose is missing, and there are crow's feet.

The enigma of this portrait is that its discovery went unheralded in the copious archaelogical literature which attended the discovery of the necropolis adjacent to the Basilica di S. Paolo fuori di Mura. In the years 1897 and 1898, when the necropolis was uncovered during the excavation of the area in preparation for a water conduit, there were several methodical reports detailing the discoveries in the area, which included loculi, ollae, and such banal finds as a bronze ring, meriting mention in the excavation reports in the *Notizie degli Scavi*. Other more remarkable finds, including the painted rear walls of three of the niches with figural decoration, are in the collection of the Museo Nazionale Romano. In the next reports, of 1901 and 1909, the portrait is also notably absent. It was acquired, along with the portrait of a woman from this same area, on April 8, 1910, while the area continued to be excavated.

The most complete report of the archaelogical activity in the area is provided by G. Lugli in 1919. Even in this thoroughgoing analysis of the site, the portrait is not acknowledged, although a Trajanic portrait of a woman in the Museo Nazionale Romano is (NSc [1919] 323 fig. 18). It is possible that the portrait was recovered from private hands after it had been traced to the tomb complex; Bolsari notes in 1898 that each columbarium had already been visited by tomb robbers, and had two or three holes in it (185-191). Furthermore, a gold ring with an incised double head of a satyr and maenad is known to have come from the Via Ostiense at this time, but was acquired from a terrazziera (pavement layer) on April 4, 1912 (inv. 58198), and such may have been the fate of the two Antonine portraits from the Via Ostiense, which could have been retrieved by unauthorized excavation and acquired by the Museo Nazionale Romano shortly thereafter.

This man was is all probability a private individual commemorated in a bust-length depiction. The sculpture would have been inserted into a niche with an identifying inscription below it, like those which filled the Vigna Codini columbarium II. We know that the burials extended into the second century through the survival of inscriptions from that period as well as through the presence of sarcophagi.

The several columbaria along the eastern edge of the Via Ostiensis were for the most part small family sepulchres, unlike the more ample tombs dating from the end of the Republic through the Julio-Claudian period such as those in the Vigna Codini. The portrait busts are thus more likely to have been placed in niches and remained there than to have been displaced through the resale of burial plots. In addition, the station of the deceased may be assumed to have exceeded that of the burials along the Via Latina – containing members of the middle class rather than slaves and servants – although we are still lacking information about the origins of this as a funerary region.

Bibliography: Felletti-Maj, 228. Neg. no. DAI Inst. Neg. 7232-7233

For the necropolis, see G. GATTI: NSc (1897) 335-36; *NSc* (1897) 418-19; *NSc* (1897) 454-456; NSc (1897) 512-18; NSc (1898) 24-30; NSc (1898) 65; *NSc* (1898) 185-191; G. LUGLI, Scavo di un sepolcreto romano presso la Basilica di S. Paolo, *NSc* (1919) 285-354; LANCIANI (1917); R. KRAUTHEIMER et al., *Corpus Basilicarum Christianarum Romae, The Early Christian Basilicas of Rome,* vol. V (Vatican City 1977) 111-112.

M.L.A.

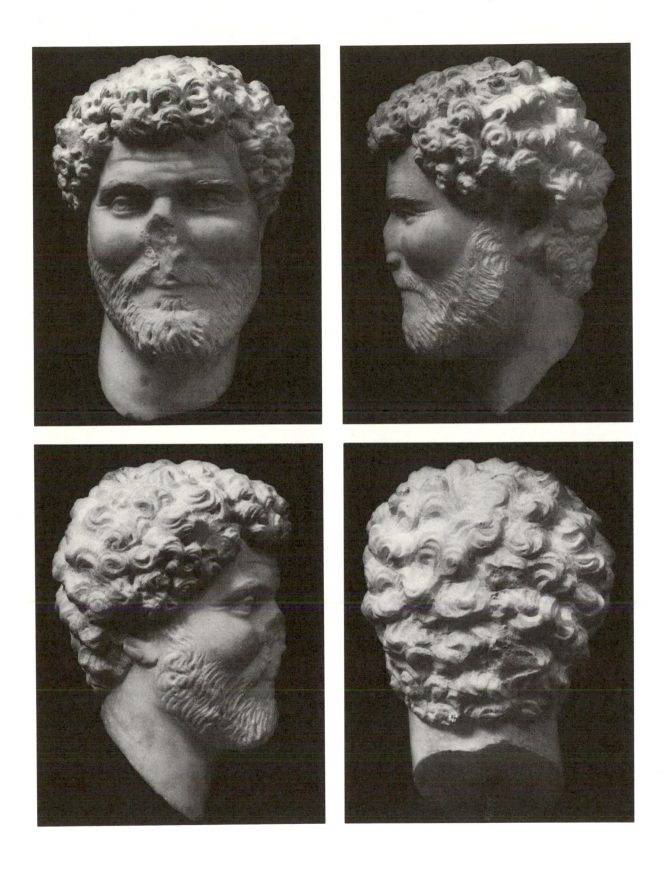

Early fourth century A.D.
Luna marble: h. 25 cm.
Provenance: Rome, from the foundations of n. 6, via Cheren (Property of S. Bellini)
Discovered in March of 1938 and acquired on May 19, 1939
Inv. n. 124531

The round-faced portrait was split vertically in front of the ears and the two halves reattached. There are twin vertical lines above the nose, and crow's feet. The pupils are in the form of kidney beans, and the heas is cursorily worked in back.

This perhaps Constantinian image of a man in Eastern style is carved in Luni marble. It was discovered in March of 1938, in the course of constructing a new building on the right side of the Via Cheren, about fifteen meters from its intersection with the Via Nomentana, north of the Aurelian wall, and about two meters below street level.
Together with the portrait was found a variety of objects, including a head of Priapus (MNR inv. 124532), [1] the lower part of a statue (MNR inv. 124533), an acephalic marble bust (inv. 124524), and enough funerary sculpture to suggest that the context was indeed sepulchral, and may have been a hypogeum.
The funerary material recovered from the site included the following objects: a fragment of a strigilated sarcophagus with a central cantharus, a bunch of grapes, two doves, one drinking and the other with its head raised (124536), [2] a rectangular travertine funerary stele (124293); additional travertine funerary stelai (121294; 121292; 124582; 124581); and a Christian funerary stone (124589: Ferrua, RevArchChrist 21 (1945) 196 ff.
The preponderance of funerary material, which postdates for the most part the decorative sculpture recovered in the same area, and the presence of a sarcophagus of probably pagan character together with the avowedly Christian funerary stone (124589) makes it likely that this was the site of a mixed burial of pagan and Christian remains during the late third century and early fourth century. The religious beliefs of the sitter cannot therefore be known, but he was certainly interred alongside Christians and pagans during this remarkable period in the history of the Roman world.

[1] H. 12 cm.; neg. 201897L.
[2] H. 48 cm., W. 1 m. Neg. AFS 101176. End of the 3rd. c. A.D. Published: M.N.R. *Le Sculture*, 1, 2, pp. 106-109, n. 15; For a comparable sarcophagus in Berlin, Staatliche Museen, see O. Wulff, *Altchristliche und mittelalterliche byzantinische und italienische Bildwerke* I (Berlin 1909) p. 7, no. 12, inv. 2735, H. 62 cm., w. 2.15 m., d. 68 cm.; discovered in Rome in 1903.

Bibliography: B.M. Felletti-Maj, 313; Felletti-Maj, NSc (1947) 78, fig. 1.

Neg. nos. GFN E 26577; Museo B 3959; DAI Inst. Neg. 1941.1926-1928

Cf.: Athens, Olympeion, M.N. 378, L'Orange fig. 17, Bieber no. 2387; Sabratha, Museum, DAI Inst. Neg. 61.2140; Stolen from imperial fora, DAI Inst. Neg. 74.2702.

M.L.A.

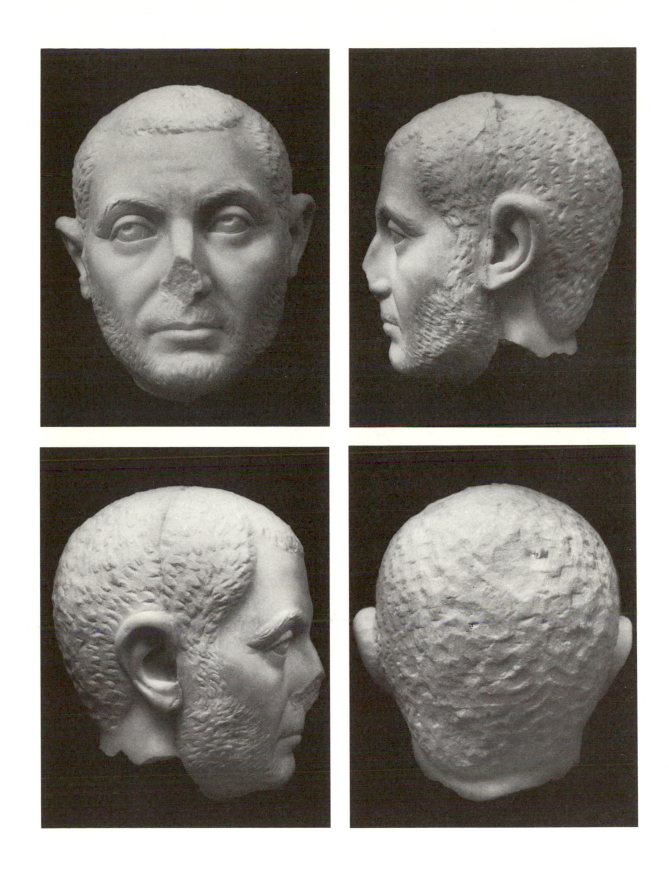

Index

MUSEO NAZIONALE ROMANO